The PGA
TOUR

A LOOK BEHIND THE SCENES

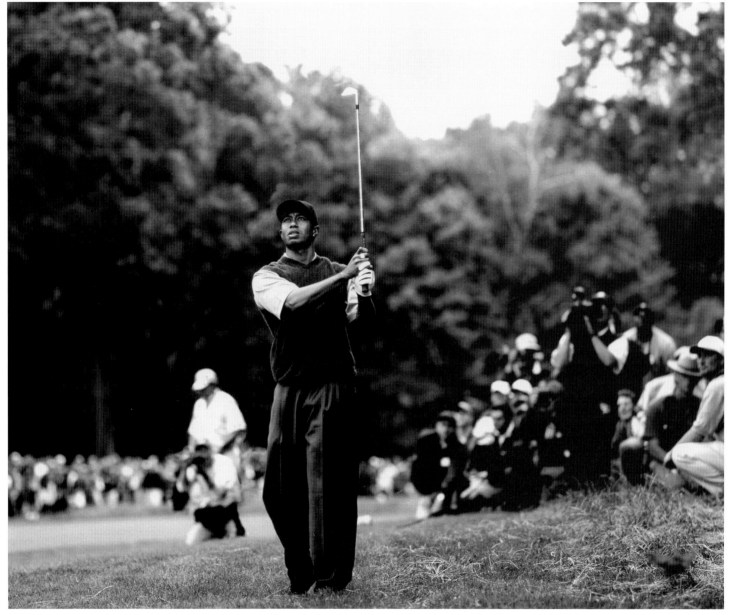

TIGER WOODS IN THE ROUGH, NO. 2—U.S. OPEN

The PGA TOUR

A LOOK BEHIND THE SCENES

PHOTOGRAPHS BY DICK DURRANCE II

TEXT BY JOHN YOW

Foreword by Timothy W. Finchem
Commissioner, PGA TOUR

**Andrews McMeel
Publishing**

Kansas City

The PGA TOUR: A Look Behind the Scenes was produced by
Lionheart Books, Ltd.
5105 Peachtree Industrial Boulevard
Atlanta, Georgia 30341

Design: Carley Wilson Brown

ISBN: 0-7407-3328-1

Library of Congress Cataloging-in-Publication Data

Durrance, Dick
 The PGA tour : a look behind the scenes / photographs by Dick Durrance II ; text by
John Yow ; foreword by Timothy W. Finchem.
 p. cm.
 ISBN O-7407-3328-1
 1. PGA Tour (Association) 2. PGA Tour (Association)--Pictorial works. 3.
Golf--Tournaments--United States. 4. Golf--Tournaments--United States--Pictorial
works. I. Yow, John Sibley, 1948-II. Title

GV969.P75D87 2003
796.352'06--dc21 2002038588

ATTENTION: SCHOOLS AND BUSINESSES
Andrews McMeel books are available at quantity discounts with bulk purchase
for educational, business, or sales promotional use. For information, please write to:
Special Sales Department, Andrews McMeel Publishing, 4520 Main Street, Kansas City, Missouri 64111.

The PGA TOUR

DEDICATION

This book is for my parents,
photographer Margaret Durrance and filmmaker Dick Durrance,
who gave me the instincts, education, and inspiration to create it.

My mother, whose irrepressible enthusiasm for adventure took her to the far corners
of the world, instilled in me the dictum "nothing ventured, nothing gained."
To this day, the words ring in my ears when I confront a significant choice.

From my father, a true champion on skis, as a filmmaker, and especially in life, I acquired
a passion for striving with intensity and grace to do my very best.

—Dick Durrance II

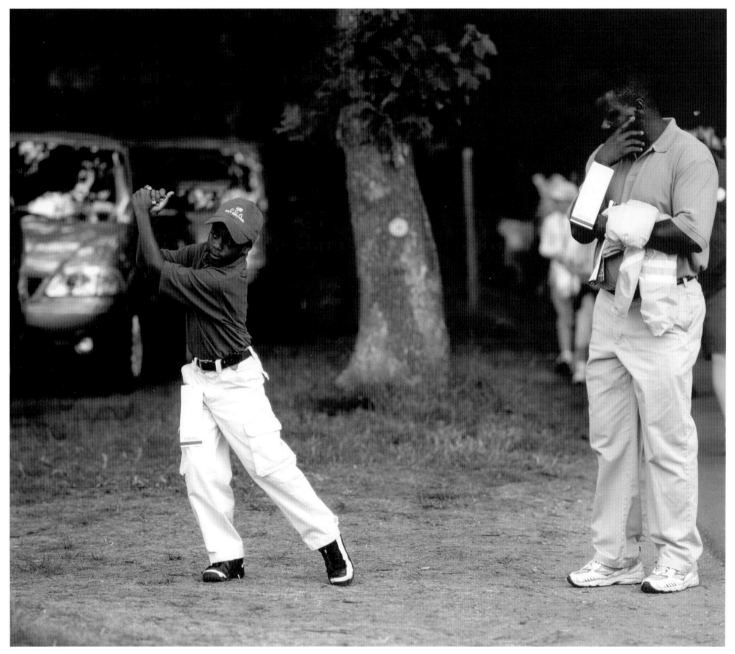

SON SHOWS FATHER HIS SWING SHOT—U.S. OPEN

Foreword

Timothy W. Finchem
COMMISSIONER, PGA TOUR

Dick Durrance first came to us with the concept of looking beyond the pure competition of the PGA TOUR, to delve into the spirit and personality of the TOUR. It is something we experience on a weekly basis, the tireless behind-the-scenes efforts that make it all come together in communities throughout the country.

Having thoroughly enjoyed Dick's photo essay in *Golfers*, I very much was looking forward to the images he would capture over the course of a season on the PGA TOUR.

As expected, Dick made the most of his time on the road. In *The PGA TOUR: A Look Behind the Scenes*, he uncovers the true essence of the TOUR through his candid portraits of the players, fans, volunteers and tournament staff.

From a big-picture point of view, the popularity of the TOUR and our players continues to grow, both here and abroad, as we continue to welcome outstanding young talent and an increasing number of international players, a terrific complement to our wealth of established stars. PGA TOUR telecasts now are seen in more than 140 countries, tournament attendance continues to grow and our fan base increasingly is becoming more diverse.

But what often escapes the public view is what Dick manages to capture in *The PGA TOUR: A Look Behind the Scenes*: The countless hours competitors put in to compete at this world-class level, their efforts to live ordinary lives with their families while living half of the year on the road, and the strong tournament organizations and dedicated volunteer forces that work year-round to prepare for and then operate each event.

Charity is a driving force for drawing the thousands of volunteers throughout the country, for they know that every PGA TOUR tournament generates a significant amount of money to support causes in the local community. In fact, our all-time charitable contributions surpass $700 million. It is a mission everyone associated with the TOUR takes very much to heart.

So as you enjoy the photo artistry of Dick Durrance in the following pages, realize that the images you see are played out virtually every week on the PGA TOUR schedule. And that the faces you see reflect more than people who are simply focused on providing four or five days of competition. They reflect players, fans, volunteers and officials who are dedicated to community, charity and truly making a difference in the lives of others.

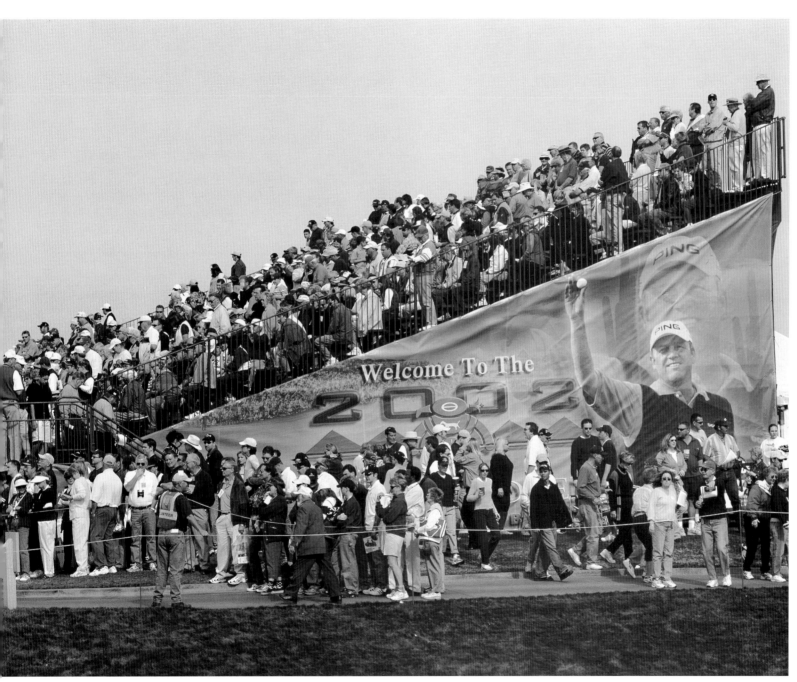

BANNER FEATURING PREVIOUS YEAR'S WINNER, MARK CALCAVECCHIA, WELCOMES FANS TO THE 1ST TEE—PHOENIX OPEN

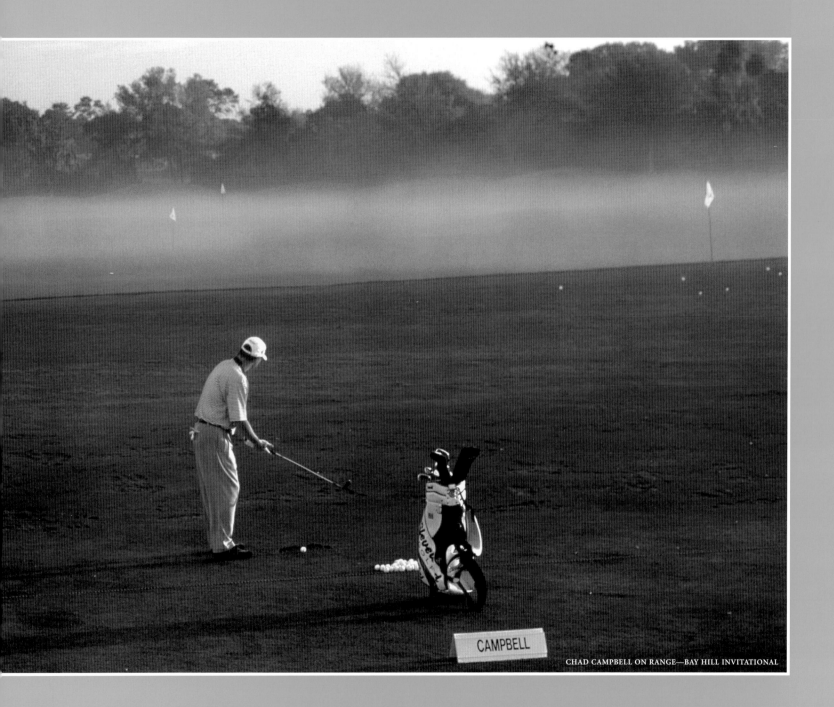

CAMPBELL

CHAD CAMPBELL ON RANGE—BAY HILL INVITATIONAL

The Players

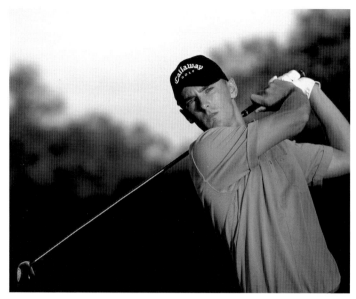

CHARLES HOWELL, TEE SHOT NO. 7—BAY HILL INVITATIONAL

After the "West Coast Swing," the PGA TOUR moved to Doral in Miami at the first of March and by the middle of the month had worked its way up the coast to "Arnie's place" for the Bay Hill Invitational in Orlando. Tiger Woods was the two-time defending champion. Was it time for a new face?

Chad Campbell, the 2001 Player of the Year on the BUY.COM Tour, seemed poised to make a splash in the big pond. After rounds of 70, 70, and 68, he started the final only two strokes behind Tiger, but Campbell blew to an 80 on Sunday to finish tied for 31st.

Charles Howell, another of the TOUR's rising stars, also started fast, with a 71-69 in his first two rounds. He was still in contention after a 74 on Saturday, but disaster struck on Sunday. A quadruple-bogey on No. 6 and a triple on the finishing hole added up to an 82, a round he described as "ridiculous."

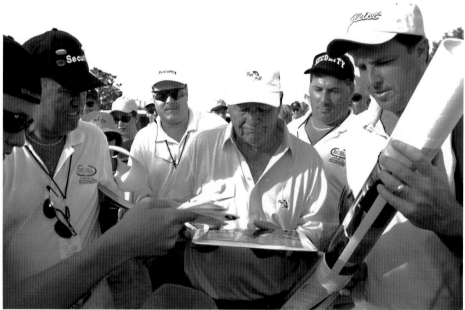

ARNOLD PALMER SIGNING AUTOGRAPHS—BAY HILL INVITATIONAL

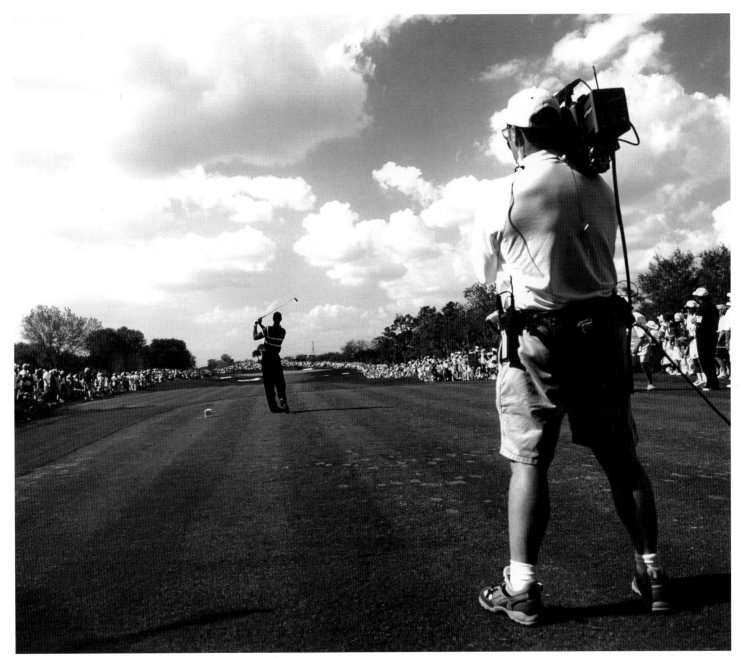

TIGER WOODS, TEE SHOT NO. 7—BAY HILL INVITATIONAL

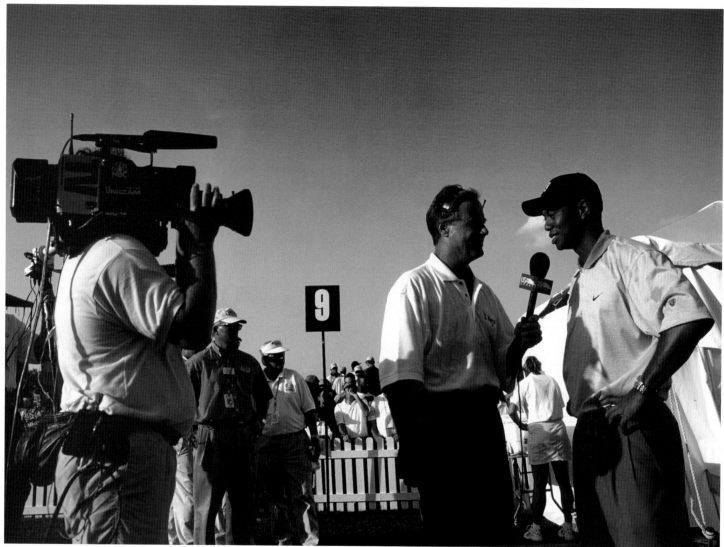

TIGER WOODS, INTERVIEW FOLLOWING SECOND ROUND—BAY HILL INVITATIONAL

In the end, the world's No. 1 player, Tiger Woods, prevailed for the third straight year, with a little help from No. 2 Phil Mickelson, who bogeyed four of the final five holes. No. 14 marked the beginning of the end for Lefty. He bogeyed while, two holes behind him, Tiger was birdieing No. 12. It was a two-shot swing that gave Woods the lead for good. Tiger's game face was on.

The following week the TOUR moved up the coast to Ponte Vedra, to the tournament they call the Fifth Major. It's The Players Championship (TPC), staged on the brutal Stadium Course at the TPC at Sawgrass, and it brings together as strong a field as any tournament in golf. Would this be John Daly's time? Always a huge crowd favorite, Daly had gripped it and ripped it back into the top 50, a comeback highlighted by top-10 finishes at the Phoenix Open and the Buick Invitational earlier in the year. The previous week he had finished 15th at Bay Hill. But this wasn't going to be Daly's week after all. Big John opened with a 76 and missed the cut by one stroke.

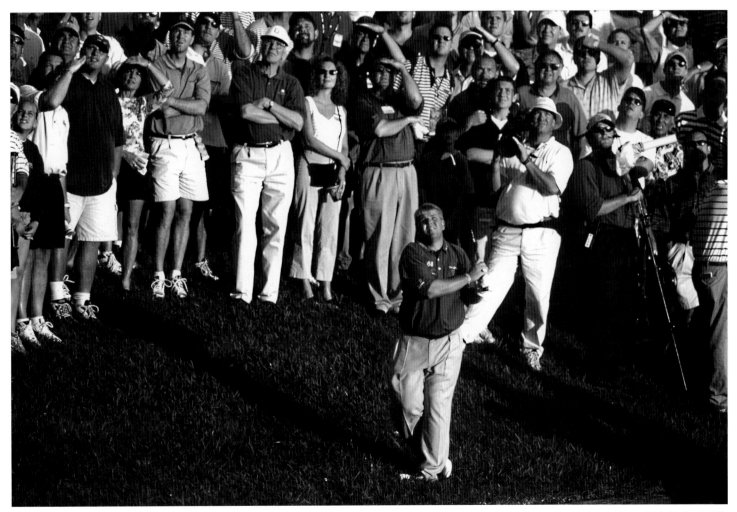

JOHN DALY, SECOND SHOT OVER TREES, NO. 18—THE PLAYERS CHAMPIONSHIP

The Big Easy, sweet-swinging South African Ernie Els, was a pre-tournament favorite, but opened with a 76. A 69 on Friday brought him back into contention, but Els moved the wrong way on "moving day," with a horrendous 79 Saturday.

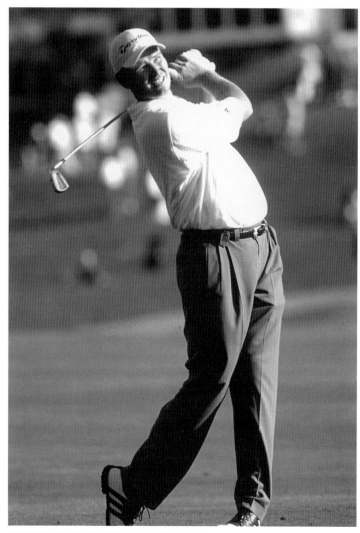

ERNIE ELS, FAIRWAY SHOT NO. 18—THE PLAYERS CHAMPIONSHIP

DAVID DUVAL, NO. 17—THE PLAYERS CHAMPIONSHIP

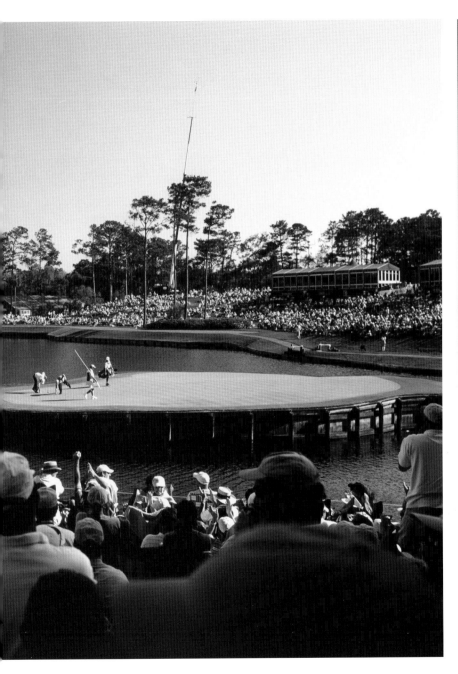

PADRAIG HARRINGTON, TEE SHOT NO. 8—THE PLAYERS CHAMPIONSHIP

David Duval, having broken into the "major" winners' circle at the British Open the previous summer, opened with a 68, one of Thursday's lowest rounds. But Duval wouldn't break par the rest of the week and finished back in the pack.

Ireland's Padraig Harrington, star of The European Tour, stayed close to the top of the leaderboard through two rounds. Harrington opened with 70-72, but faltered with a 77 on Saturday to drop out of contention. Campbell's 68 on Friday moved him up the leaderboard, but a 74 on Saturday dropped him back, and an even-par 72 on Sunday could bring him only a tie for 11th.

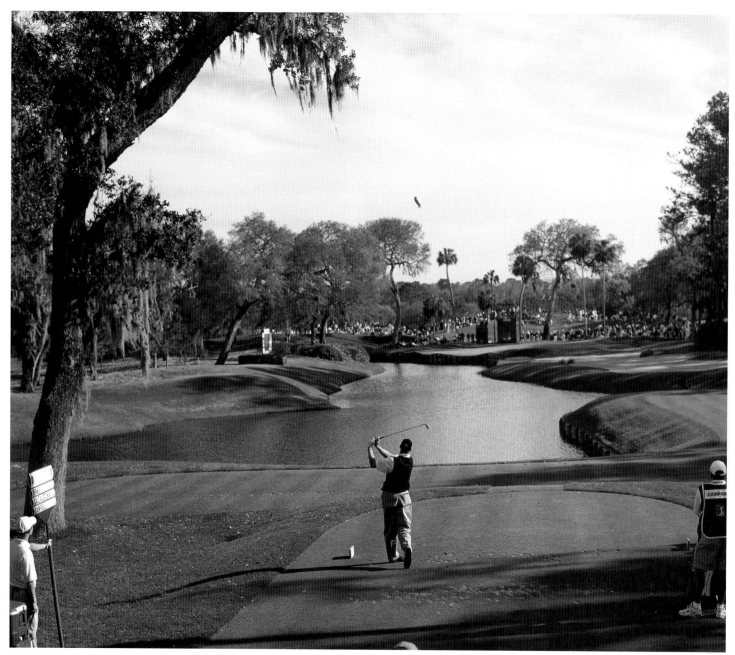

CRAIG PERKS, TEE SHOT NO. 13—THE PLAYERS CHAMPIONSHIP

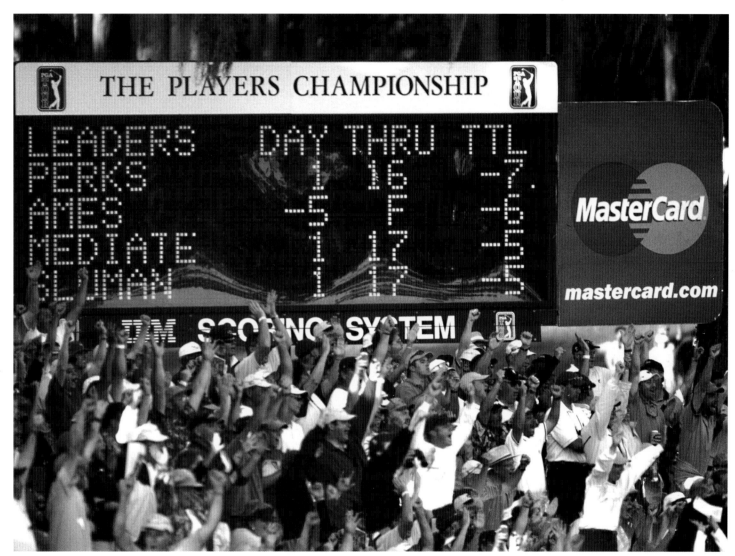

THE PLAYERS CHAMPIONSHIP

LEADERS	DAY	THRU	TTL
PERKS	1	16	-7
AMES	-5	F	-6
MEDIATE	1	17	-5
BLUMAN	1	17	-5

IBM SCORING SYSTEM

MasterCard

mastercard.com

CROWD CHEERS PERKS' BIRDIE PUTT IN ON NO. 17—THE PLAYERS CHAMPIONSHIP

When all was said and done, the tournament belonged to unheralded—and largely unknown—New Zealander Craig Perks, who came into the week ranked No. 203 in the world. Coming down the stretch on Sunday, his eagle chip-in on 16, birdie on 17, and miraculous par-from-the-rough on 18 will be remembered as one of the season's most incredible finishes.

A few weeks later the TOUR landed in Texas for the Verizon Byron Nelson Classic, the tournament that honors one of the game's great gentlemen and great players. Nelson won 54 PGA-sanctioned tournaments during his career, including the incredible record of 11 in a row in 1945.

TOUR veteran Brian Henninger came to the event looking for good things to happen. A poor 2001 season, in which he lost his TOUR card for the first time since 1996, was spilling over into 2002, with four missed cuts in his five events leading up to the Nelson. Henninger started strong, with 67-68 on the first two days, but with a pair of 71s over the weekend, he dropped to a still-respectable tie for 22nd.

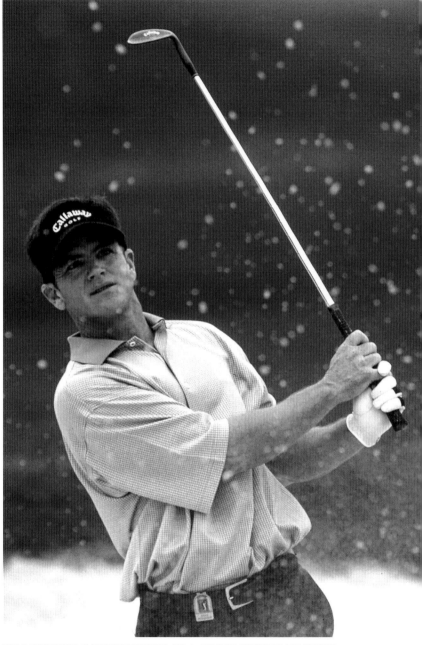
BRIAN HENNINGER BLASTS FROM BUNKER, NO. 4—VERIZON BYRON NELSON CLASSIC

Phil Mickelson, having already won once in 2002, looked like a good bet to make it twice after a stunning 64 on Friday, but disappointing weekend rounds of 71-71 dropped him back into a tie for 17th.

The storyline—and the tournament—belonged to "the Smilin' Assassin," Japan's Shigeki Maruyama, who opened with a 67, followed with a stunning 63 and never looked back. With his second PGA TOUR win, Maruyama became the first-ever Asian player to win more than once on the American tour.

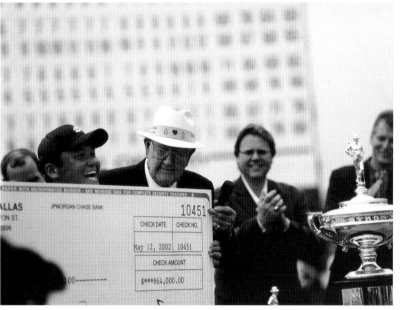

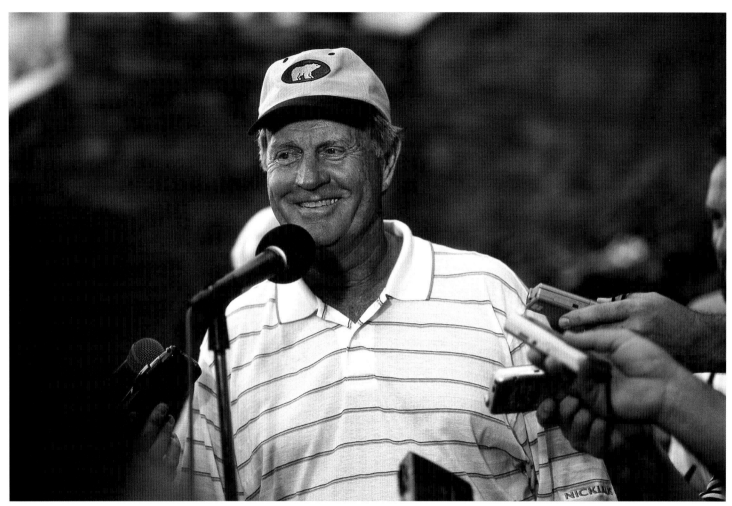

Two weeks later another living legend was in the spotlight, as the TOUR came to Jack Nicklaus's Memorial Tournament at Muirfield in Dublin, Ohio. Although Tiger Woods came to town as the three-time defending champion and—in the opinion of some— already the greatest golfer ever, the Golden Bear's eighteen major championships still have him enshrined alone at golf's summit.

After two 2nd-place finishes and one 3rd already this spring, Brad Faxon, "the man who has never missed a putt," came to Muirfield looking for his first win of 2002. He played with typical consistency, but his 70-69

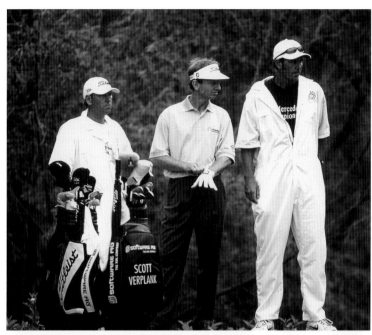

BRAD FAXON & CADDIES, NO. 18—THE MEMORIAL TOURNAMENT

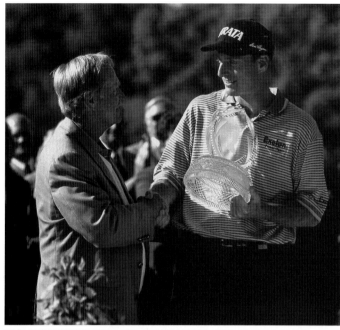

HOST JACK NICKLAUS CONGRATULATING JIM FURYK—THE MEMORIAL TOURNAMENT

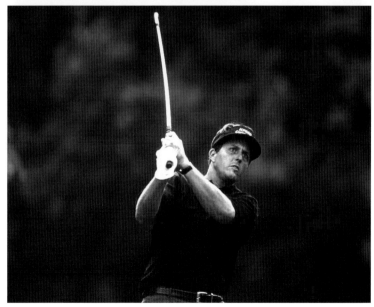

PHIL MICKELSON, TEE SHOT NO. 18—THE MEMORIAL TOURNAMENT

on the weekend kept him one stroke out of the top 10.

Phil Mickelson, having finished 3rd three times in the previous five tournaments, played well again, tying for 9th place with a 69 on Sunday.

Billy Andrade was also among those 9th-place finishers. His impressive 67-67 on the weekend gave him his third top-10 finish of the year but kept him looking for his first victory since 2000.

With Tiger having faded early, it was Jim Furyk, using his renowned driving accuracy, who took home Jack's trophy. He also used a chip-in for birdie and a holed bunker shot for eagle on Sunday's back nine to pull away from the field with a superb final-round 65.

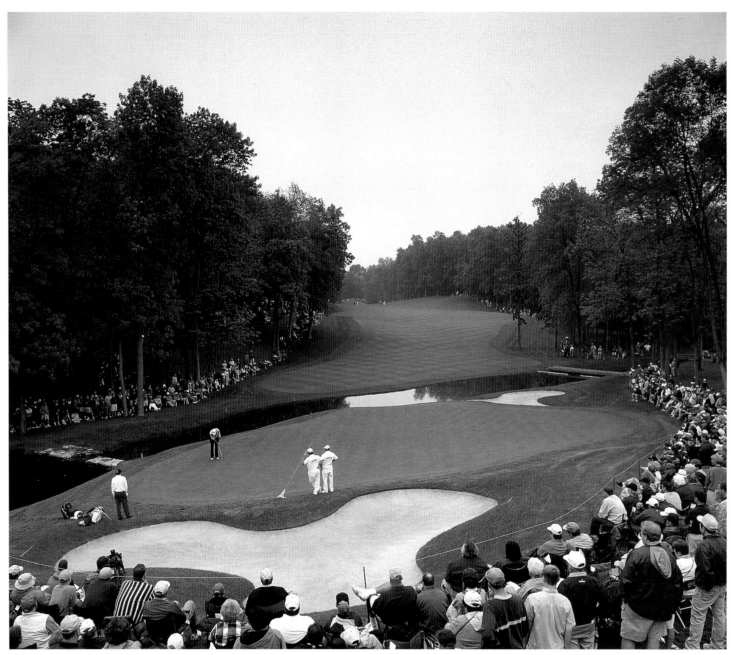

BILLY ANDRADE & LEN MATTIACE AT NO. 9—THE MEMORIAL TOURNAMENT

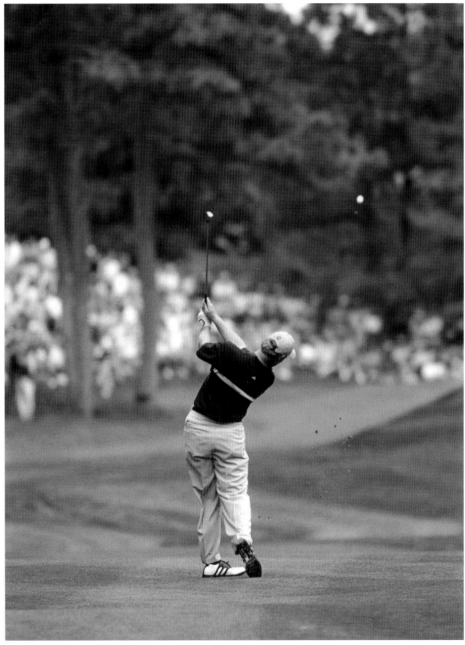

The International, at Castle Pines Golf Club in Castle Rock, Colorado, is the one tournament of the year where the highest score wins. Bogeys and doubles drop you into "red figures," while birdies are worth two points, eagles five, and double-eagles eight.

Ernie Els, the 2000 champion (and record holder with 48 points) stayed in contention through Saturday but failed to make a move on the final day. Likewise, Sergio Garcia, the irrepressible Spaniard, racked up an incredible 19 points on Saturday to climb up the leaderboard, but early bogeys on Sunday knocked him out of the running.

ERNIE ELS, FAIRWAY SHOT NO. 8 (ABOVE); SERGIO GARCIA & ELS VISUALIZE SHOT (RIGHT)—THE INTERNATIONAL

It was another former champion, Steve Lowery, who made Sunday interesting. Lowery had a double-eagle (holing out from 200 yards on the par-5 17th), an eagle, and a birdie over his last five holes on the way to 16 Sunday afternoon points.

But it wasn't enough. Rich Beem dropped in a 15-foot putt for an eagle on 17 that held off Lowery's furious charge and gave the exuberant Texan his second TOUR victory. (Beem's third title, The PGA Championship, would come two weeks later at Hazeltine.)

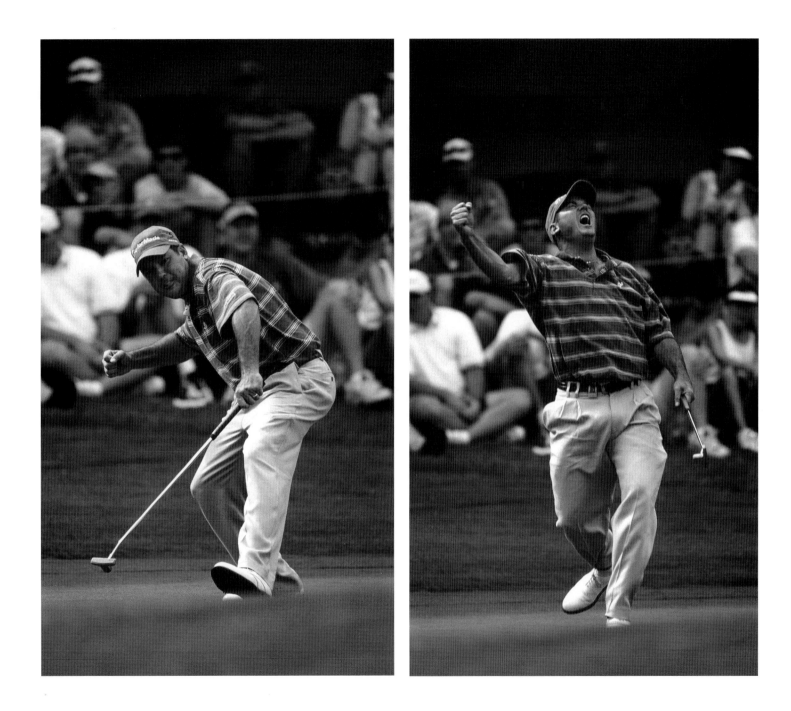

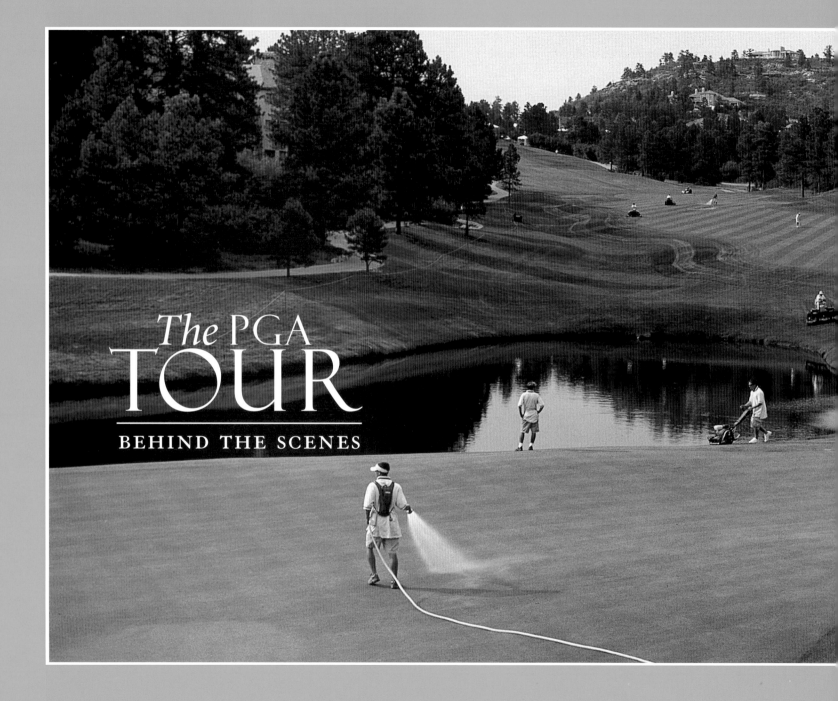

The PGA
TOUR

BEHIND THE SCENES

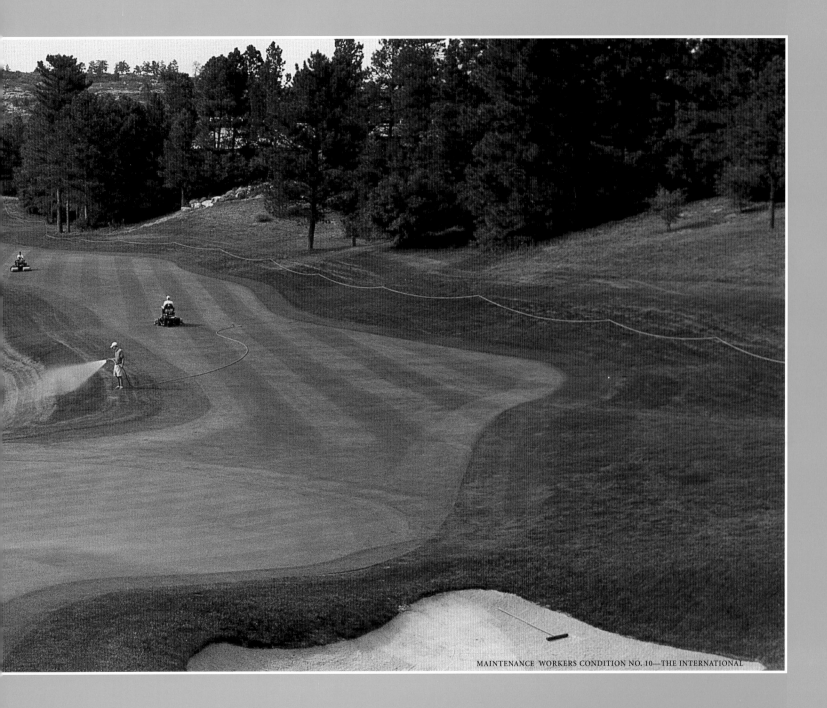

MAINTENANCE WORKERS CONDITION NO. 10—THE INTERNATIONAL

Preparing the Course for Play

Fred W. Klauk Jr.
GOLF COURSE SUPERINTENDENT, TPC AT SAWGRASS

Two things lured Fred Klauk, Jr. to the University of Florida: an incredible golf program and an outstanding agronomy/turf grass curriculum.

"I didn't quite make the team," he says, "since those were the years [late '60s and early '70s] when players like Andy Bean, Andy North and Gary Koch were leading the Gators to national championships. But that was okay because I needed to study."

Study . . . and work on golf courses. "I really loved it," says Klauk. "I worked on golf courses the whole time I was in college, and came to realize that I really enjoyed working outside, being out with nature. I don't really like office work." Apparently, it runs in the family. Klauk's son Jeff—one of four highly athletic children—is playing on the BUY.COM Tour.

After working with or for other superintendents for several years, Klauk decided it was time to have his own course. "I got an interview at Pine Tree Golf Club," he recalls, "and I found out just before I went in that one

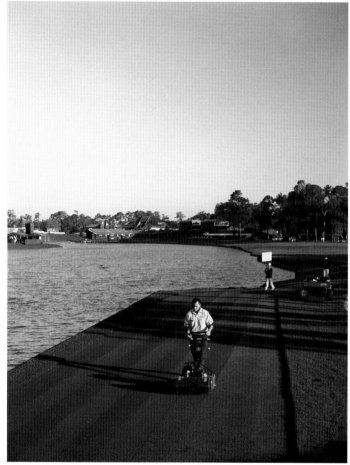

JUSTIN JONES MOWS 18TH TEE—THE PLAYERS CHAMPIONSHIP

of the gentlemen on the interview committee was Sam Snead. My first major interview, and I'm sitting five feet away from one of the real legends of all golf."

Klauk got the job, and, during his ten years at Pine Tree, learned a useful lesson. You weren't likely to win Snead's money on the golf course. "Sam was notorious for winning all his bets on the first tee," recalls Klauk, "because he negotiated all the shots before he went out."

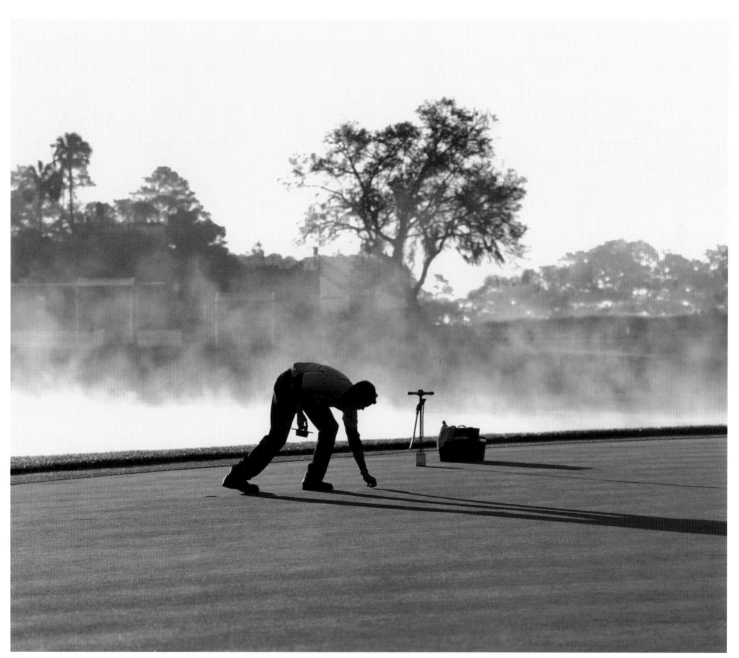

AIDAN BECK CUTS HOLES AT PUTTING GREEN—THE PLAYERS CHAMPIONSHIP

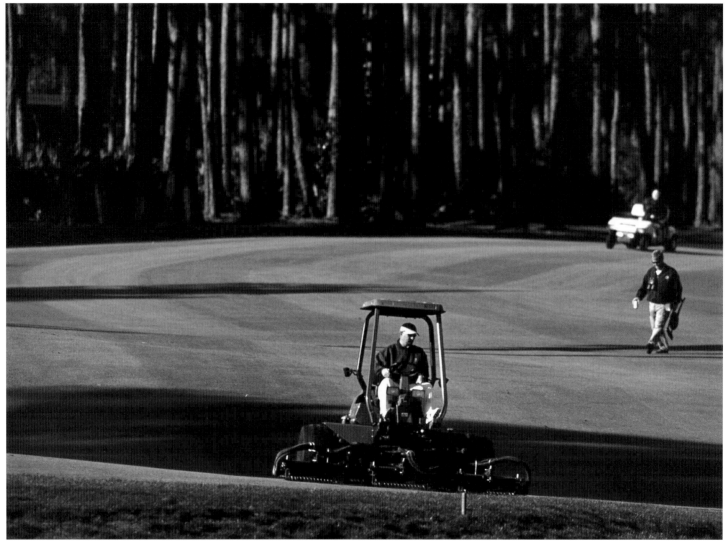

But Klauk also learned from his association with Snead that he really wanted to go to a golf course that staged a PGA TOUR event. That dream was realized when he was hired on at TPC at Eagle Trace. "And I guess I did something right," recounts Klauk, "because two years later [then-tour commissioner] Deane Beman asked me to come up here to Sawgrass to help save the golf course from recent disaster from a tournament they

had had and get it back in condition for the championship. When they had trouble again the following year, he asked me to come up here permanently. I've been here for now for sixteen years."

Only by working on a course designed for tournament play, says Klauk, can you learn what it means to set up a golf course properly. "And that's really the most fun," he adds, "learning how the rules staff of the PGA TOUR sets up a golf course according to their vision of how the game is supposed to be played. And, of course, we do try to push the envelope—to challenge the players to be the best player that week for that event."

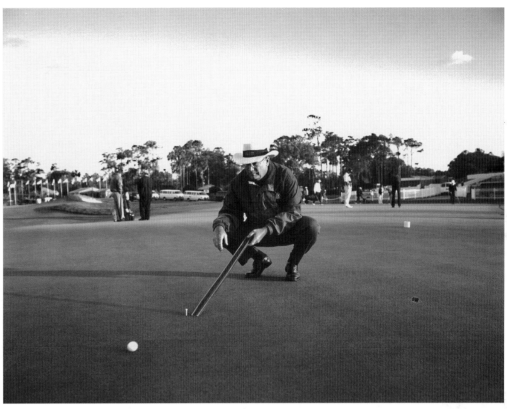

FRED KLAUK MEASURES GREEN SPEED WITH STEMPMETER—THE PLAYERS CHAMPIONSHIP

How is the course different come tournament week? Green speed, says Klauk. "On a day-to-day basis, we try to maintain the greens somewhere between 9 and 10 on the Stempmeter, and for the championship we try to get them somewhere between 11 and 12. That's pretty normal, you know, throughout the major tournaments today. It's one of the ways we can really challenge the players."

Klauk is quick to credit advances in mowing equipment for making this kind of fine-tuning possible. "The grinding equipment that sharpens the blades has

become so sophisticated now. We used to do all the grinding by hand, but it's all automated now to where you can get precision down to thousandths of inches."

For fans curious about how the Stempmeter works, Klauk offers a simple explanation. "You find the levelest part of the green, roll three balls down the meter's inclined plane in one direction, then roll them in the opposite direction, average the distances, and there's your reading."

Anything over 10 is fast, says Klauk, and 12 is "very fast."

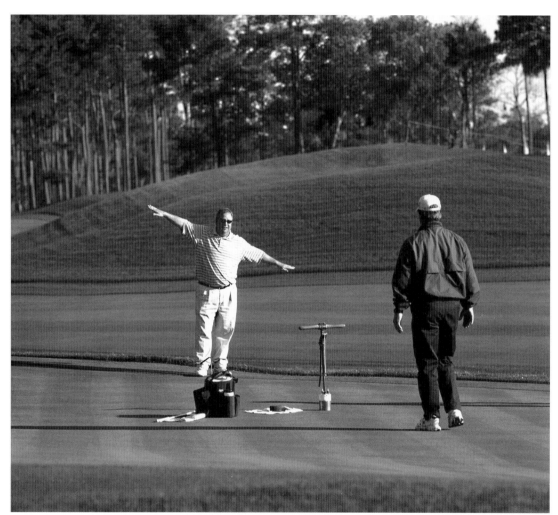

Sawgrass as part of an internship program that allows foreign students the chance to get experience with American courses.

"It's a very good program for them and very good program for us," says Klauk.

Klauk is equally meticulous when it comes to the care of his fairways. They are mowed every day, to exactly 3/8 of an inch. "Normal is closer to a half-inch," says Klauk, "but we keep ours at 3/8 all year round because a lot of the TOUR professionals practice here. We cut them every afternoon after play is completed."

After fifteen years at Sawgrass, Klauk remains steadfast in pursuit of his unchanging goal: to make the course better every year. So far, he has succeeded, and he takes justifiable pride in the accomplishment.

"We have actually taken the course to the next level, and done it without spending a whole lot of money."

Cutting the cups is another of the thousand painstaking tasks associated with preparing the course for play. For The Players Championship, Klauk is getting expert help from Aidan Beck, a South American exchange student enrolled in Ohio State's golf course maintenance program. Beck has come to the TPC at

Jon Brendle
PGA TOUR RULES OFFICIAL

Of course, the hard work that people like Fred Klauk do has to be signed off on by the PGA TOUR, represented by TOUR rules officials like Jon Brendle.

Brendle is quick to point out that making rulings during play is a relatively small part—40 percent, he estimates—of his job. A good portion of his time goes into overseeing the course set-up.

"I'm involved in selecting both the tee-marker positions and the hole placements for every day of the official event," he explains. "And prior to that, we work very closely with the superintendent on course conditions. We actually send an agronomist from the TOUR a week ahead of time. We tell them how fast we want the greens, and how close we want the fairways cut and all that kind of stuff."

It's also up to Brendle and his fellow rules officials to cancel competition if the weather gets too bad. "We're the ones who decide whether the course has become unplayable, as well as when to resume play," he says.

The rules officials also pair the players and assign starting times, dictate the prize money breakdown and tell sponsors and vendors where they put their hot dog stands and expo tents. "All these people have to have our blessing," says Brendle.

And then, of course, there is the responsibility of making rulings, a job both delicate and demanding. In this largely player-governed game, rules officials don't need to be "witch hunters," says Brendle. "We don't ride

JON BRENDLE SETTING PINS—THE MEMORIAL TOURNAMENT

"We actually send an agronomist from the TOUR a week ahead of time. We tell them how fast we want the greens, and how close we want the fairways cut . . ."
—Jon Brendle

"The integrity of these players is never in question. After all, they have to live with each other."—Jon Brendle

field and make sure he gets the appropriate penalty. That's what we mean by protecting the field."

Needless to say, it's not always easy. Brendle recounts the incident at this year's Bay Hill Classic when Dan Forsman's caddy got involved with another player's improper drop procedure. "Dan didn't know about it," says Brendle. "Dan wasn't even around, didn't even see it, and didn't realize that he had been penalized a stroke for it. As a result, he signed an incorrect scorecard and was disqualified."

Fortunately for Brendle and his colleagues, this is golf—where the cardinal rule never needed to be written down: Play with integrity.

"The integrity of these players is never in question. After all, they have to live with each other. If I were to win a medal and then find out that I had inadvertently made a mistake, I would give it up right away. In baseball, if I slide into home and the umpire calls me safe even when I know I'm out, I would run to our dugout cheering that the umpire had blown the call. That's baseball, but that's not our game. We don't want to win like that. We want to win only when we played better than you.

"When all is said and done," says Brendle, now in his thirteenth year as a rules official, "golf is still a pretty neat game."

around looking for infractions. The players call on us when they need us."

"The ideal," Brendle explains, "is to protect the field. If a guy has called me in for a ruling, I am first his lawyer, and it's my job to try to not get him a penalty. But if I judge that he has in fact broken a rule, then it's my job to become the lawyer for everybody else in the

Security

Given the spectacular glamor and high visibility of today's typical PGA TOUR event, rules officials like John Brendle are not the only group of people who have to be there "just in case." So do a large contingent of security officials.

With media personalities at every turn—not to mention their millions of dollars worth of equipment, including cameras, lasers, and the most sophisticated computer technology—with thousands of fans, including young children, in attendance, and with some of the world's best-known sports celebrities highlighting the competition, it's no surprise that security is a high priority.

Like rules officials, they hope they won't be called on, but you can be sure they are there—sometimes on

NEW YORK STATE POLICE—U.S. OPEN CHAMPIONSHIP

horseback, sometimes on bicycles, sometimes on rooftops, and sometimes inconspicuously walking the grounds. And based on the number of "incidents" reported—i.e., practically zero—they're doing a fine job.

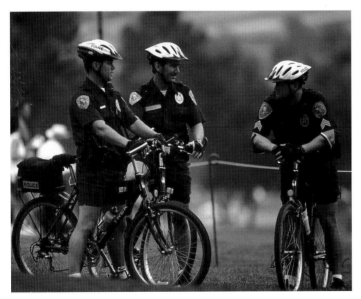

BICYCLE POLICE—BYRON NELSON CLASSIC

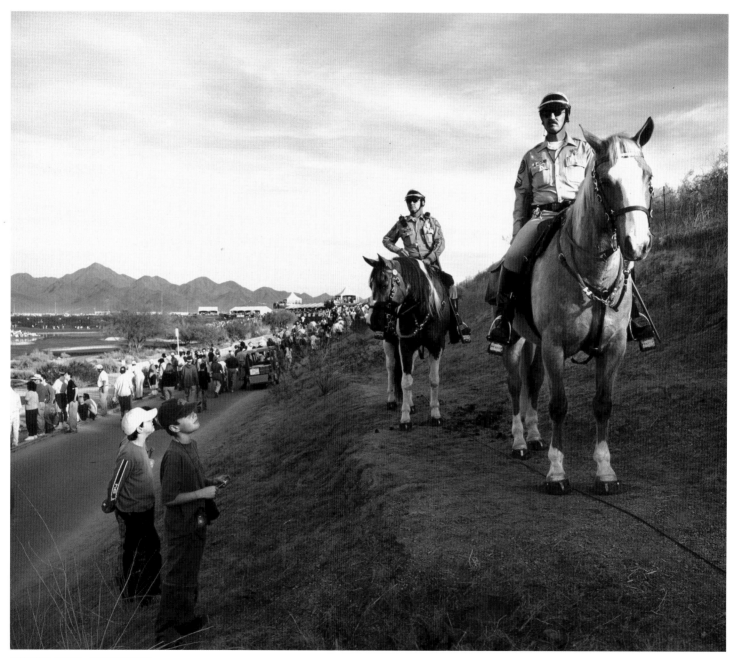

MOUNTED POLICE—PHOENIX OPEN

Pampering, Anyone?

Eric Hilcoff
TRAVEL COORDINATOR FOR THE PGA TOUR

If you're going to have a golf tournament, somebody has got to get the players to the right city on the right day, and for the last 12 years, Eric Hilcoff has been that somebody. Well, not the only one. Actually, the PGA now has 14 full-time travel coordinators.

But week in and week out, Hilcoff says he handles the travel arrangements for anywhere from 50 to 100 of the touring pros.

While we earth-bound nine-to-fivers might enviously assume that, these days, all the TOUR players travel in their own planes, Hilcoff is quick to correct that misperception. Only 20 to 25 percent of the players travel

ERIC HILCOFF BOOKING TRAVEL ARRANGEMENTS, CASTLE PINES GOLF CLUB
—THE INTERNATIONAL

in their own planes, he says, and even that statistic is misleading. "Actually," he clarifies, "most of them don't have their own planes; they're in lease programs. And even the players in the programs don't use their planes every week. It's when they are traveling with their families that the leased plane is really a great amenity."

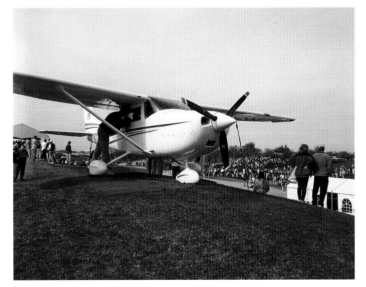

PLANE ON DISPLAY NEAR HOLE NO. 1—PHOENIX OPEN

". . . once guys miss the cut, they'll want to get out—maybe go home or maybe go to their next destination."—Eric Hilcoff

Hilcoff is distinctly qualified to help other folks travel. The Jupiter, Florida, resident is on the road 40 weeks a year. "Thursday to Sunday is my work week," he says.

His job would be a lot easier if everybody stayed around until the golf tournament was over. But in golf tournaments, of course, half the field is cordially invited to depart after Friday's second round.

"It even starts Thursday night," says Hilcoff. "The guys who have a bad first round are already looking at what's going to be available Friday night or Saturday morning. And once guys miss the cut, they'll want to get out—maybe go home or maybe go to their next destination, so it all kind of overflows from there into the next week. I mean, between Thursday morning and Friday night, these guys will change their minds six or seven times."

Eric has been at it for a dozen years because he loves working for the players, loves working for a great organization like the PGA, just loves what he does.

But is he any good at it?

"Absolutely not," jokes popular CBS analyst and Senior Tour player Gary McCord. "When you're trying to book a flight, when you're in dire need, you won't find him. He's out playing golf, he's out running, he's out doing something. Only time you can find him is, like, on Tuesdays from 9:30 to 9:45."

Henry Luna
CALLAWAY TECHNICAL REP

Henry Luna, a technology representative for golf equipment manufacturer Callaway, shows off a sophisticated piece of gadgetry—Callaway's version of a

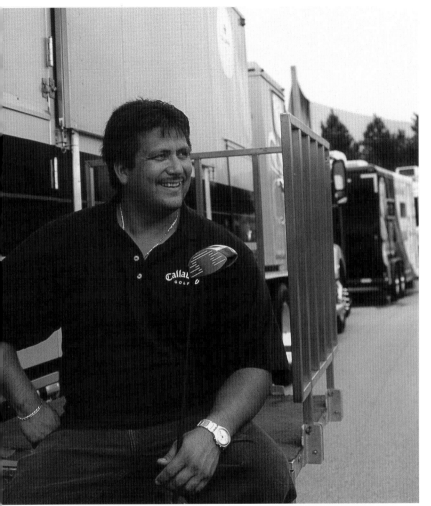

HENRY LUNA ON STEPS OF CALLAWAY TOUR VAN—BYRON NELSON CLASSIC

LOFT-LIE MACHINE IN CALLAWAY TOUR VAN

equipment trailer at about 36 events a year ("Or more," he adds, "if I skip over to an LPGA or a Senior Tour event.")

Henry's been with Callaway for six years, and this is his second full season on the road. He calls traveling with the TOUR "a great adventure and definitely challenging."

The years he spent "inside Callaway," were a necessary prerequisite, says Henry, because that's where you learn how the machinery operates. "All the machinery we have in here is actually a smaller version of what we have inside the factory. Since the machines in the factory are too big to take on the road, we just condensed everything. Like this smaller version of all of our grinding machines," he explains. "We use exactly the same materials that we do in the factory, just on a smaller scale."

Henry describes the service he provides to the players as "very technical. What we do in here has to be just right, because the players can definitely tell the difference."

But, then, working closely with the players is, for Henry, a major perk. "They're all great guys," he says, "and out here on tour with them, it's like we're all just good friends."

loft-lie machine. "It measures anything we want," says Luna. "It allows you to duplicate down to the numbers." He adds, "According to Calloway's specifications, this is on the money. That's what we all want to go by, that right there."

Like so many whose livelihood revolves around golf, Henry is an itinerant. He's in the Callaway

Paul Loegering
EQUIPMENT REP AT THE
BYRON NELSON CLASSIC

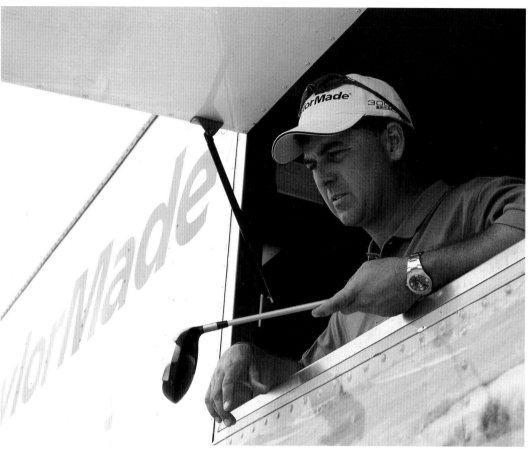

PAUL LOEGERING AT WINDOW OF TAYLOR-MADE TOUR VAN—BYRON NELSON CLASSIC

Our job is to take care of the players entirely," says Paul Loegering, who represents manufacturers of golf equipment and clothing. "We do all their golf apparel—the shoes, the shirts, the hats—and we do all their equipment, including balls. So what we're offering is customer service from head to toe."

Meeting the equipment needs of TOUR players is a job not likely to be appreciated by the weekend golfer. "You've got to service these guys' clubs on a daily basis," explains Loegering. Taylor Made, he says, has close to forty players using its irons, "and these players will want to change their grips every third tournament, and their irons will change from the thousands of golf balls they hit. We keep a profile of what their clubs are, and check their worn-out grooves every third or fourth tournament. Plus, guys are constantly trying different shafts on their metal woods, so we are working on that every week."

In the fiercely competitive world of equipment manufacturing, it's not just a question of keeping the players happy. It's a question of keeping more players happy than the other guy. The quest for newer, better equipment never ends, nor does the tally of "who's using what."

"We'll build forty to sixty woods a week," says Loegering. "They might not all go into play, but they're there, for trying a different shaft or what have you. Taylor Made leads in drivers used every single week, and

we win the iron count just about every week. So we have the most players in the field every week using our product. That's good, of course, but we stay busy.

As Loegering explains, for example, the 40 players using Taylor Made irons are by no means using the same irons. Customization is the name of the game. "Every

"Believe me, what you as a 12-handicapper require is very different from what Ernie Els requires."—Paul Loegering

ERNIE ELS SWINGS HIS TAYLOR-MADE CLUBS AT RANGE—BAY HILL INVITATIONAL

single club in every player's bag is to his specifications— flex, frequency, overall weight, swing weight, length, loft and glide, face angle, everything. Believe me, what you as a 12-handicapper require is very different from what Ernie Els requires."

Like virtually everyone whose work supports the PGA TOUR, Loegering is intimately familiar with the nation's airports. He's on the road as much as 48 weeks out of the year. Since his work involves getting the players set to go before the tournament begins, his work week runs from Sunday to Thursday, and the days are long. "Travel on Sunday," he recounts, "work eleven-hour days on Monday, Tuesday and Wednesday, and back in the office [in California] on Thursday."

Loegering admits that the "long grind" sometimes gets tough, especially for a family man, but he feels extremely fortunate to have such a job. "There are only a handful of us in the whole country that have this great opportunity to work with the best players in the world," he says. "And it's not all work. We go out with the players, too, to sports or celebrity events. We get to create friendships with these guys, personal relationships. I really like that."

Best of all, you get to watch them swing the golf club. "Day in and day out," says Loegering, "you get to observe the little things—momentum, tempo, posture, address. If only it worked by osmosis."

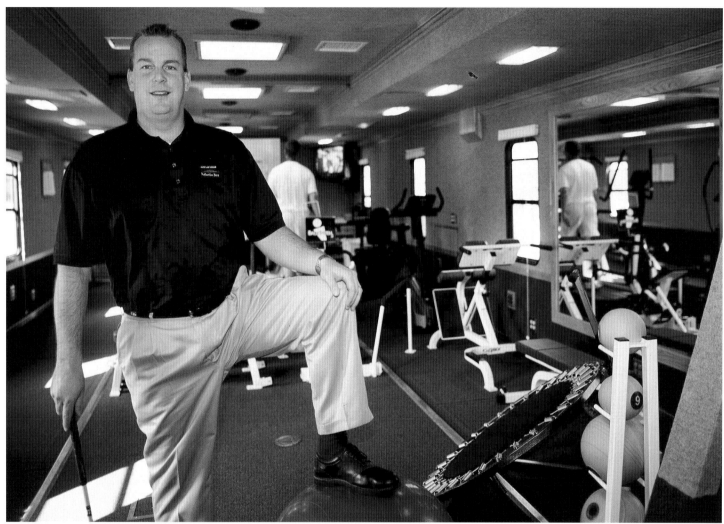

Mark Benson
THE TOUR FITNESS TRAILER

If today's PGA TOUR player fails his physical exam, he doesn't have much excuse. After all, the TOUR's fitness trailer follows him wherever he goes.

"We have two trucks that follow the TOUR to pretty much every event," says Mark Benson, athletic trainer and strength specialist for HealthSouth, which is a sponsor of the PGA TOUR. "And one of them is literally a gym that opens up on both sides."

Increasingly, players are coming to understand the importance of injury prevention. "Seeing what Tiger Woods and David Duval have done has really raised awareness," says Benson. "The idea is to be able to come out here week after week and make cuts. It can be grueling, and you really need to stay injury free."

Benson estimates that close to a half of the field will come in to work out during the week, and he's hearing more and more testimonials as to the benefits that he and his colleagues offer. "Just yesterday Jerry Pate was in here," he says, "and he told us that if he had understood fitness, if he had understood the principles we understand today, he would have been ten times the player he was. Of course, he was still a great player."

Adds fellow trainer Troy Fusevy: "Two years ago—I think it was—we were at Callaway Gardens, and David Toms came in on Tuesday. He felt so bad he just wanted us to write him a note so he would have a medical excuse for withdrawing. But we talked him out of that; we worked with him and got him fixed up, and he ended up winning that week. As you can imagine, that was a pretty fun week for us. And, you know, there are a lot of stories like that."

"Two years ago—I think it was—we were at Callaway Gardens, and David Toms came in on Tuesday. He felt so bad he just wanted us to write him a note so he would have a medical excuse for withdrawing. But we talked him out of that; we worked with him and got him fixed up, and he ended up winning that week."
—Troy Fusevy, fellow trainer

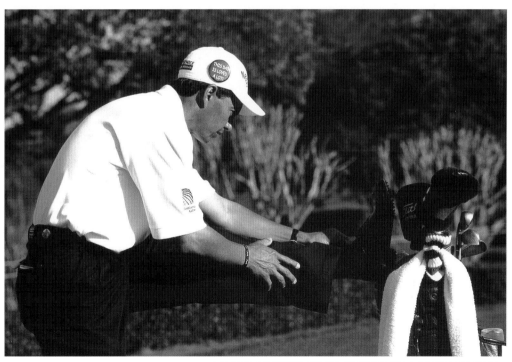

TOM PERNICE STRETCHES PRIOR TO TEEING OFF—BAY HILL INVITATIONAL

Stewart Williams

WEATHER CHANNEL METEOROLOGIST
FOR THE PGA TOUR, BYRON NELSON CLASSIC

The PGA TOUR and the Weather Channel? It's a match made in heaven.

Well, more literally, according to Weather Channel and PGA TOUR meteorologist Stewart Williams, it's a pretty smart business deal. The PGA TOUR gets something of incalculable value—the security of on-site, up-to-the-second weather forecasting—and the Weather Channel, as the official tour forecaster, gets a healthy dose of great publicity.

In fact, Williams is one of five Weather Channel meteorologists who set up shop not only at PGA TOUR events, but also at all Senior and BUY.COM Tour events. "It's my job to give up-to-date weather information to tournament officials and to the media center," says Williams. "Anybody needs weather information, I can tell them exactly what's happening."

As anybody who has been on a golf course in a thunderstorm knows, up-to-date weather information is something golf tournament officials can't have too much of. "Our real job here is to provide safety to the spectators and the players," says Williams. "If a thunderstorm is coming, it's up to us to provide enough warning for everybody to get to cover."

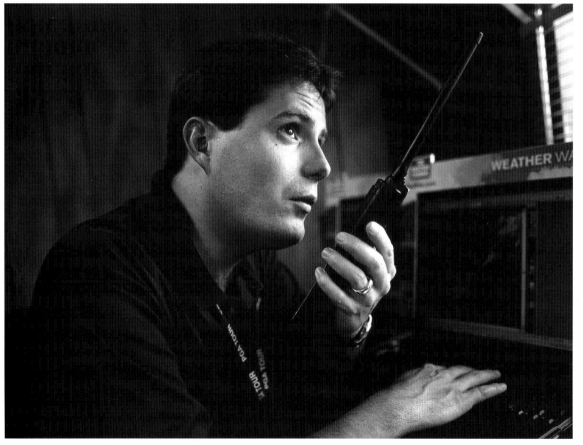

STEWART WILLIAMS AT HIS WEATHER STATION—BYRON NELSON CLASSIC

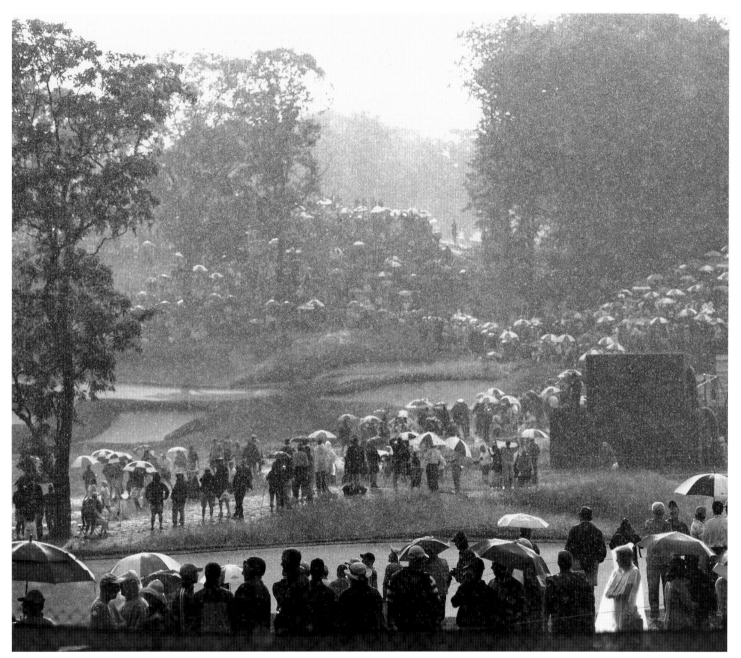

CLOUDBURST DRENCHES FANS AT 17TH HOLE—U.S. OPEN CHAMPIONSHIP

"Anything can happen out here, and that's why we're here. We'll do everything we can. We're here to help."—Stewart Williams

On this day, light rain showers have been moving across the golf course, and, says Williams, they've been watching a cell that produced lightning 60 miles southwest of the tournament site. "Everything's been moving generally from southwest to northeast—coming in our direction—so I have the evacuation plan in place. Got the vans on all over the course just in case. And if we do get into a situation where lightning is a hazard, of course we stop play."

Williams hopes that won't be necessary, but he's not going to take any chances. "We try to give 30 minutes," he says. "If it's still coming our way when our calculations say it's 30 minutes away, it's time to blow the horn. Today we're hoping this little bit of light rain will push on to the east, the guys can just keep on playing golf."

If the cell does keep coming, Williams will be watching it all the way. The computer in front of him is hooked into the National Weather Service as well as live local weather radar. Throw in the special lightning detection equipment, says Williams, "and I can tell you exactly how far away the rain is, how far away the lightning is, and how fast the cell is moving."

And then there's ThorGuard, which doesn't merely detect lightning. It *predicts* it. "What you've got," Williams explains, "is an electrostatic field. There's a charge in the clouds and charge in the ground, and when those two charges meet, that's when you get your lightning *discharge*. The program picks up on that, these two pieces of energy looking for each other, and it tells us when the charges are growing toward a lightning discharge."

Still, nature will never be entirely predictable, and Williams has some interesting memories: like the funnel cloud that passed three miles north of an event he was working a few years ago, leaving the course covered in quarter-size hail; or the tornado that blew through a Senior event on Pro-Am day, knocking over all the tents and trailers, or the two inches of snow that covered the Phoenix Open one year.

"Anything can happen out here," says Williams, "and that's why we're here. We'll do everything we can. We're here to help."

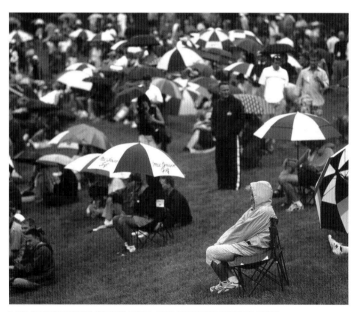

FANS BRAVE DRIZZLE AT 18TH HOLE—THE MEMORIAL TOURNAMENT

Tom Horel

LOCKER ROOM MANAGER,
CASTLE PINES GOLF CLUB

I started working here July 4th week-end, 1984," says Tom Horel proudly. "The first day the clubhouse opened."

Formerly a club professional from Michigan, Horel had managed the locker room at Butler National in Oakbrook, Illinois, and at El Dorado in Palm Springs before being hired to come to Castle Pines. Over 25 years, two generations of players have loosened their shoelaces under Horel's attentive care.

"Many, many friends," he reminisces. "And many of them out on the Senior Tour today. How great it is to see Dave Stockton out there, and then his son Junior coming along with the new generation."

Of course, Horel jokes, enough is enough. "I don't want to see the third generation. I mean, I love these guys, but that's just too long."

Besides, Horel has already been around long enough to have figured out the secret to golf's abiding appeal. "You know the old story. Every shot makes somebody happy."

TOM HOREL IN MEN'S LOCKER ROOM AT CASTLE PINES GOLF CLUB—THE INTERNATIONAL

Food Services

Donna Schultz
PROPRIETOR OF CADDY CENTRAL

So while the players are having their travel plans arranged, their clubs custom fitted, and their bodies tuned up, who's looking after the caddies? Donna Schultz, that's who.

Schultz, with the help of her husband and brother, has been operating Caddy Central for a year and a half now, though the concept has been in existence for more than a decade. Schultz says that the trailer they operate now, The Fifth Wheel, has been in service for four years.

It's actually a diner on wheels, says Schultz, and, more than that, it's a "refuge" for the caddies. "It's important for them," she says. "It's their own place, where they can unwind, kick back, get together with the guys, and talk about the day."

And it's unique. "A lot of the tournaments don't provide anything for the caddies," says Schultz, "so this is their home away from home."

Caddy Central will travel to twenty-six tournaments during 2002, covering every corner of the continental United States. "We started out in California in January, and we've been as far east as New York, as far north as Minnesota, and as far south as Florida. We bought this truck to start the year, and I know it's already got over 20,000 miles on it."

The compensation for all that time on the road, says Schultz, is getting to know the caddies, who have become sort of an extended family. "It's funny," she says. "On TV now, my husband and I spend less time looking at the pros than we do at who's caddying. They're really a great bunch of guys."

A great bunch of guys, Schultz adds, whose living is precarious. "If you're with a player that's not doing well, it's not easy out there. I mean, they can give their pro all the help in the world, but they still have no control over the outcome. It's still up to the pro to hit the ball."

But though in many ways they seem to inhabit a different world, the caddies and the pros do have one thing in common, Schultz believes: "They're in it 'cause they just love golf."

DONNA SCHULTZ SERVES HAWK NUCARR IN CADDY CENTRAL—BYRON NELSON CLASSIC

51

Brendan O'Neill
PRESIDENT OF SHANE'S GOURMET MARKET AND CATERING

Needless to say, caddies represent a very small fraction of the people who could use a bite to eat on the golf course during tournament week. That's where folks like Brendan O'Neill come in. As president of Shane's Gourmet Market and Catering, O'Neill is in charge of corporate hospitality catering and all on-site concessions at a variety of sporting events around the country, including Jack Nicklaus's Memorial Tournament at Muirfield in Dublin, Ohio.

In fact, O'Neill has been coming to Muirfield ever since the Memorial was inaugurated 27 years ago, and, yes, there's a story there. "My father had been friends with Jack Nicklaus for a long time," recalls O'Neill. "They and some other friends were sitting around one day, trying to figure out how to put on a tournament, and apparently Jack just started going around the table, saying, 'Okay, you do this, you do this.' He knew my father was in the soft drink industry, so he says, 'Hey, why don't you do the concessions?' That's how it started, and we've been here ever since."

Of course, the operation has grown over the years. "On a busy day," says O'Neill, "we'll feed from 6,000 to 8,000 people in the corporate hospitality pavilion, and throughout of the tournament we'll serve another 80,000 to 100,000 people out on the course."

The key to the operation is a mobile kitchen unit

INTERNATIONAL CULINARY ACADEMY STUDENTS AT KITCHEN TENT
—THE MEMORIAL TOURNAMENT

featuring a colossal meat cooker that, in O'Neill's words, can handle a "phenomenal amount" of food. "It can do hot dogs, hamburgers, everything—in a really short time. The food goes through on a sort of moving belt, gets fire grilled, dipped in a special sauce, then cooled down at the end. Only [executive chef] Scott Morit can tell you just how much food it can put out."

If food produced on such a scale sounds iffy, not to worry. O'Neill's huge staff of cooks, servers, bartenders, and runners includes some thirty students from the International Culinary Academy, based in Pittsburgh and affiliated with Cordon Bleu. These students not only help maintain the gourmet quality of the food; they have a ball doing it, says O'Neill. "It's a once-in-a-lifetime experience for them. A lot of the students want to come back, even after they've graduated, and do this event again."

HOSPITALITY VILLAGE—U.S. OPEN CHAMPIONSHIP

The Media

Tracy Dent
MEDIA DIRECTOR FOR THE BAY HILL INVITATIONAL

"... if Tiger Woods has just been interviewed, within 15 minutes we'll have the entire transcript ready to pass out to the writers ..."—Tracy Dent

A veteran of more than 30 years of golf broadcasting, Tracy Dent has seen some changes.

"In the 1960s, when I first started covering golf tournaments as a broadcaster, the networks used what we call static locations. That is, we covered 15, 16, 17 and 18 with a camera tower and an announcer on each one, but we had no coverage of the earlier holes. Compare that to today, when television can cover every tournament, all 18 holes, tee to green. Or better yet, there's the Golf Channel, full-time golf, 24 hours a day. Here at our tournament, and all the others too, they have their own set built right here on the property and do their shows live and on-site. ESPN, CNN/SI, USA network, all have crews here and have link-ups and feeds to do stories from the golf tournament, interviews and press conferences or what have you.

"Our interview area, for instance, now can accommodate over 100 people, and if you're not in the 100, don't worry. We have a group that does nothing but transcribe interviews. So if Tiger Woods has just been interviewed, within 15 minutes we'll have the entire transcript ready to pass out to the writers, and whether or not they heard the interview, they can quote him accurately in their articles."

Dent believes that the enormous improvement in golf coverage has not only made golf fans more knowledgeable; it has changed the demographics of the game's fan base.

"Of course, Tiger may have had something to do with it," Dent admits, "but several years ago the average age of the golf enthusiast started dropping dramatically. Not only Tiger, but a whole younger breed of golfer has come to the fore— Charles Howell III, Chris DeMarco, Sergio Garcia, David Gossett and Ty Tryon, the 17-year-old who

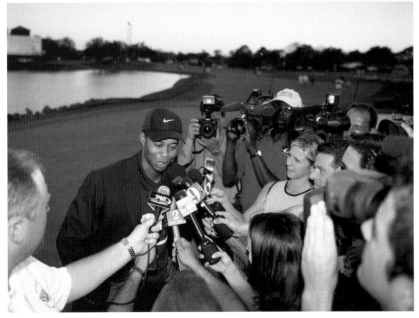

TIGER WOODS VICTORY INTERVIEW—BAY HILL INVITATIONAL

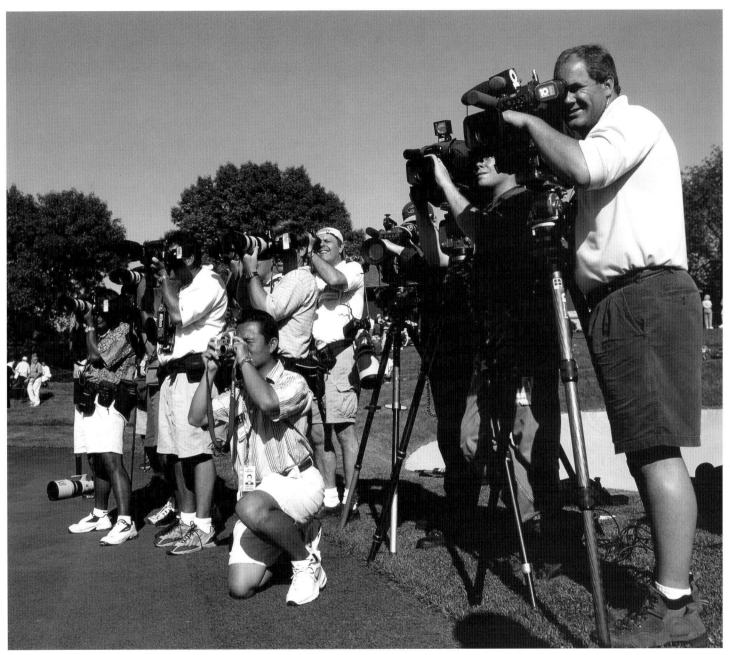

PHOTOGRAPHERS & CAMERAMEN—THE MEMORIAL TOURNAMENT

lives right here in Bay Hill. All these guys are getting a lot of exposure, and they are attracting a new group of fans."

Which brings up another remarkable change that Dent has witnessed over the years. The game has more stars now than the night sky. "Back then it was the big three," recalls Dent. "Arnold Palmer, Jack Nicklaus, and Gary Player. That's who you saw, and that's who you expected to win all the golf tournaments. Not that there weren't other good players, but those are the ones who got all the coverage. Then came Tom Watson and Johnny Miller, and they got all the attention."

Dent remembers the days when 200 players ("we called them rabbits," he says) would show up for the Monday qualifying round, hoping to fill one of the 20 available spaces. The difference today is, 2,000 players could conceivably qualify.

Drastic change has come to the media center itself, of course, and Dent recalls those bygone days with some amusement. "When I first started covering golf," he says, "they would bring us a loaf of bread and a big stick of baloney, put it on a tray, and that would be the media center." Of course, back then "the media" consisted of a dozen or so guys from the local stations.

Things are different today, what with full dinners served in the media center's own dining room to an overflow, international crowd. "Today we issue around 223 credentials to people from all over the world," says Dent, "newspaper and magazine people, all the broadcast media. And with the Masters coming up, we have half a room full of European writers. Plus, there are so many

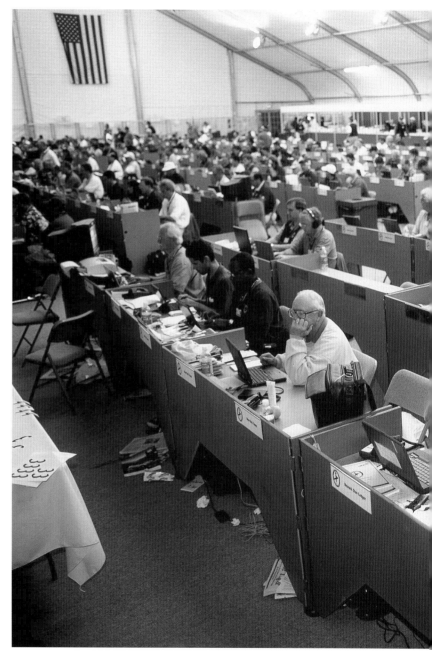

MEDIA CENTER—U.S. OPEN CHAMPIONSHIP

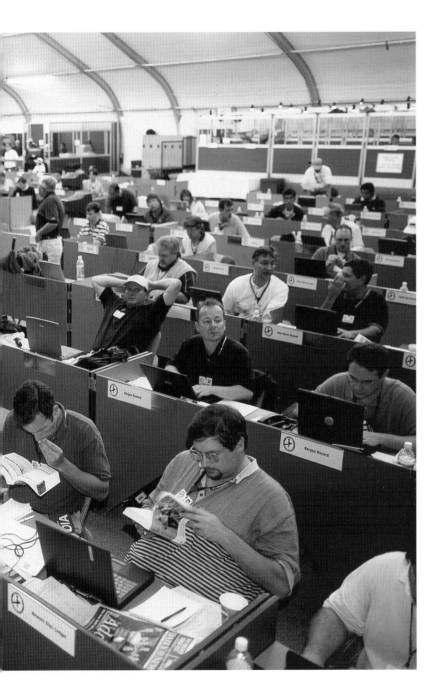

Japanese players these days that Japan has its own network here—totally separate from this media center."

Dent has known Arnold Palmer, the gracious host of the Bay Hill Invitational, for decades, and for all those years he has admired The King's fighting spirit.

"I would have hated to have to compete against him when he was young. He's a bulldog, determined to win. He's still that way," says Dent. "His game is, well, different. The way he swings the club is not the way you would teach it. But he worked so hard at it, and wanted to win so badly. That's what frustrates him today—even at 72 years old he still wants to win and thinks he should."

And as for Arnie's Army, Dent has a theory as to why they're still marching. "The thing is, he has always understood what the fans do for the game, how important they are, just like the fans know how much Arnie has done for the game. He's extremely charismatic, but he treats fans with respect, and they love him for that."

An old-timer like Dent still marvels at the high-tech smorgasbord inside today's media center: "It's unbelievable," he says. "We've got 200 work stations in here, every one with a computer. Instant access, real-time scoring right off the course, breaking news stories. The PGA provides this for all the tournaments now. The people in here never have to move from their seats. It's all right there. The PGA has got a whole other crew now, the computer guys who come in and set all this up every week."

"In the old days," Dent adds, "we had runners scrambling all over the course trying to keep us up, and even then we didn't know what was going on."

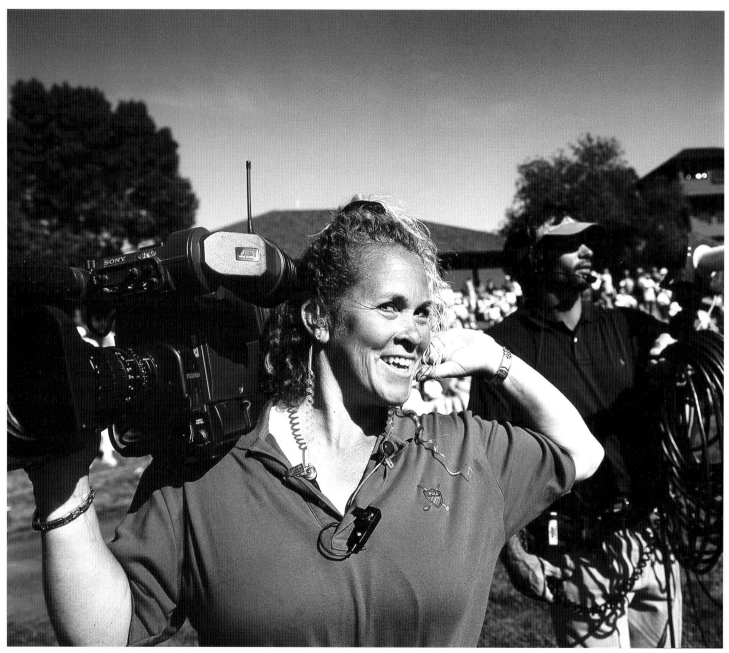

KERRY BROOKS—THE MEMORIAL TOURNAMENT

Kerry Brooks
CAMERA OPERATOR FOR CBS SPORTS

Kerry Brooks makes no bones about it. She's a woman in a man's world. And it hasn't been easy.

"If you took a look around," she says, "you'll see that I'm pretty much the only woman out here on the road. Or look around in my compound; it's all men. And yes, it's been a battle. When I started, it was like, 'Hey, she's not strong enough,' or whatever. So I've had to prove myself the whole way."

While winning the respect of her peers, Brooks has also, after eight years of shooting golf tournaments, developed a great rapport with the fans and the players. "The fans sometimes look surprised to see me running up with all this heavy stuff all over me, but I'm usually with some guy who's struggling to keep up, and they get a big kick out of that."

The fans enjoy chatting with her, she says, when she has a chance to sit still for a few minutes, and they enjoy it even more when the players stop to join in. "I've been around so long that all the players know me, and of course that makes me look good in the fans' eyes."

After getting her degree in telecommunications broadcasting from Chico State in California, Brooks interned at a local ABC affiliate. When she decided that a local affiliate wasn't where she wanted to be, she went free-lance. Her work was good enough to catch the eye of the folks at CBS, the network that hired her nine years ago.

When Brooks is shooting, her aim is to reveal the essential personalities of these great competitors, but

"After you've done it for a while, you get to know the flight of the ball. Of course, it helps if the players hit it where they're supposed to."—Kerry Brooks

within the bounds of professionalism. "I never try to show anything negative," she says. "I have a real problem with that, and I also don't want to invade their space." It's not that hard to figure out, she says: "you shoot until you know that you shouldn't, and then you walk away."

Of course, Brooks' camera is one of many on the golf course, and the fact that the viewers at home can see only one camera person's work at a time can be frustrating. "The thing is," Brooks explains, "you don't know if anybody is watching what you are doing. You might be running around at a hundred miles an hour, and nothing you're doing is making air because everybody's following something else." But then suddenly the "tally light" on Brooks' viewfinder will come on, and she'll enjoy the gratification of knowing that it's her shot that's going out live over the airwaves.

Brooks says she freaked out the first time she was supposed to follow a golf shot, but that, too, has become second nature. "After you've done it for a while," she says, "you get to know the flight of the ball."

She pauses to adjust her load. "Of course, it helps if the players hit it where they're supposed to. It's the bad shots that are hard to follow."

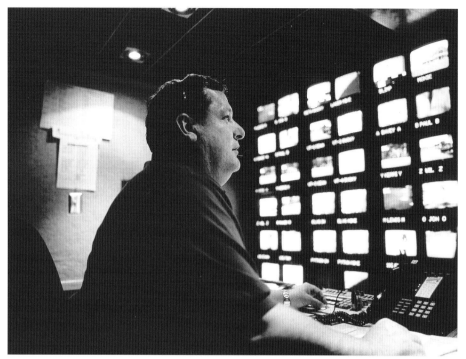

Lance Barrow
COORDINATING PRODUCER, CBS SPORTS GOLF

So, then, who decides when Kerry Brooks' shot is the one people all over the country see?

CBS Coordinating Producer Lance Barrow does. He's the guy sitting inside CBS control, with a hundred screens banked on the wall in front of him, deciding every split second which image is most crucial to the telecast.

How does he do it? Well, certainly his background as an athlete—he played football and baseball through college—helped him develop the right instincts, but exactly how it happens still mystifies him.

"They used to ask Barry Sanders how he made this certain move of his, and Barry would answer, 'I don't know how I made that move.' That's kinda the way it is in here. I really don't know how we do it."

One thing he does know. That old sports cliché, to be "in the moment," doesn't apply to Barrow and his crew. "No, we can't be in the moment," he says. "We've got to be about three moments ahead—especially in golf."

To help grasp the sheer enormity of a televised PGA event, sometimes a simple body count helps. Barrow says that CBS takes close to 130 people on the road to cover a golf tournament, and their equipment fills seven trucks. Of course, that's just for the week-to-week events. "When we do the Masters and the PGA Championship, we go up to close to 400 people."

There is the occasional glitch, admits Barrow. "Like when Gary McCord asks David Feherty, 'What's he hitting here, David?' and there's no answer from Feherty. That's a problem."

But if moving seamlessly from one on-air personality to the other sometimes casts Barrow in the role of "traffic cop," he says that that's all part of a job he wouldn't trade for any other in the world.

"I get to work every day with very talented people and great friends, and that's the best part of this job."

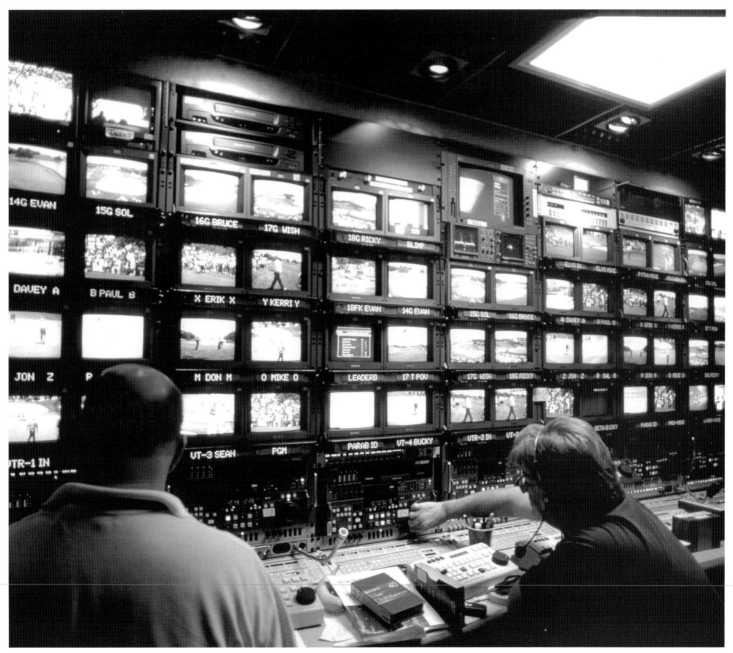

CBS CONTROL CENTER

Peter Kostis

CBS ANALYST, IN THE
WINNER'S CIRCLE WITH JIM
FURYK AT THE MEMORIAL

Among those very talented CBS personalities is Peter Kostis, who, in addition to being one of the network's golf analysts, is also a longtime teaching professional. Regardless of the number of hats he might wear, however, golf fans everywhere know Kostis as the man who gets to interview the tournament winner the second the last putt has dropped.

He considers it a rare privilege, encouraging the triumphant player to share the emotion of

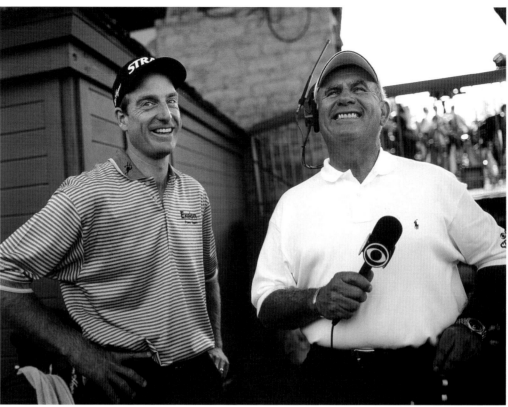

WINNER JIM FURYK & PETER KOSTIS

such a supreme moment. "The thing is," Kostis explains, "you never know how it will happen. It might be a runaway; it might be a playoff; it might be, you know, a guy blowing shots down the stretch but still hanging in there to win. But however it happened, he did better than anybody else in the field and came out the winner, and my job is to try and get some of that emotion out of the player and let the people at home have an idea of what he's feeling."

The secret to his success in these interviews is that he has taken the trouble to get to know the players. He

illustrates with the story of Lynn Mattiace, this year's winner at Los Angeles, whom Kostis says he has known well for many years. Kostis remembered the year Mattiace almost won The Players Championship in 2000—"until he collapsed there toward the end." And Kostis knew that Mattiace's mother had been watching, seriously ill at the time, and that she died a few months later.

"So in the winner's circle at Los Angeles, I just tried to let it all come out," says Kostis. "I said to him, 'Lynn, with all that you've been through, with what happened at The Players Championship, and then with your

mom, how does it feel now, succeeding now?' And you saw him take a deep breath, you saw him think about it, you saw the tears well up a little bit. You know, these guys put in a lot of work hoping to someday end up in the winner's circle. And when they do, it's our job to try and take the viewer there with them."

Kostis reflects on the interesting disparity between his two kinds of work. In teaching, he explains, he tries to help players control their emotions. "If you can't control your emotions, you can't control your golf swing, or your golf ball, and you're not going to be any good." But in the winner's circle, it's time to blow up the dam. "Then it's all about letting their emotions go," says Kostis, "and letting them be visible for people to see, so the viewer can share the experience."

Kostis's work has been golf for more than 25 years, but the thrill hasn't diminished. That's why you'll find him—if he has his druthers—down on the course instead of up in the tower.

"I just love that sense that David Feherty and I have of being right there in the middle of the action as we follow the players on the ground. And getting to interview the winner the minute he's won—that's really a special feeling."

David Feherty
ON-COURSE ANNOUNCER FOR CBS

David Feherty, another member of CBS's popular and talented golf crew, walks the course with the players, offering up-close commentary on their lie, their club selection, and whatever dangers attend the shot they're considering.

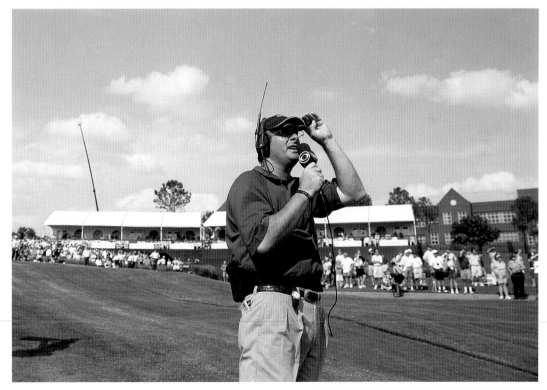

DAVID FEHERTY AT 17TH HOLE—BYRON NELSON CLASSIC

job with CBS, that doesn't come around very often. When it came up, I just jumped at it."

This sense of being part of a close-knit group also helps Feherty ignore the fact that every word he says is being listened to by millions of viewers. "It's like we're five or six guys sitting in the grill room talking about the golf on the TV screen, and we try to make it like that." The only time he's acutely conscious of being an announcer, he says, "is right after I've said something really stupid."

Aside from the all-important British accent, Feherty credits his success to having a great relationship with "virtually every player and every caddie out there, which is what

A TOUR player himself until the early nineties, Feherty credits Gary McCord with getting a microphone in his hand. "I was playing the International when McCord invited me up to his tower at 15. I just sat there and looked at him and thought, well, he's a moron. If he can do this, I can do this."

Actually, Feherty and McCord are close friends, along with Peter Kostis and the rest of the team. Feherty says their great camaraderie is the biggest reason he took the plunge into broadcasting.

"It's really fun to be a part of," he says. "I mean, I was still 37, still playing fairly well at the time, but the

makes my job so much fun." It also gets him a lot of cooperation. "When the guys see me there, first of all they know they are doing something right. And most of them get it—they understand that the show is about information, and making it entertaining and informative for the viewers. The caddies, in particular, give me a tremendous amount of help."

Feherty believes that, more than other professional athletes, pro golfers understand the whole picture—"that this is a show, and that it's essential that people enjoy watching it, and that the players need to be human, to make fun of themselves."

The only time he's acutely conscious of being an announcer, he says, "is right after I've said something really stupid."

He cites Ernie Els—"just a big friendly guy, the anti-star"—as an example. "We just did a piece on him for our last highlight show of the year, where's he's in bed with a claret jug [his British Open trophy] and a golden ferret, which is my version of an Oscar, that I had given him as Player of the Year. It's the end of the show, and he rolls over, kisses the claret jug, says, 'Goodnight, claret,' turns over, kisses the ferret, says, 'Goodnight, ferret,' and then turns the light out. Try to get that done in baseball."

And how about the "Tiger Factor"? What impact does that have on the "show" that is televised golf? In a word, tremendous.

"The thing is," says Feherty, "Tiger does something astonishing—make that two or three astonishing things—everytime I follow him, things I know no one else on the planet is capable of doing. I mean, you're looking at something really special when you see Tiger play."

Reflecting on it, Feherty adds that anybody in the top 125 can win—as long as Tiger isn't playing well. "If Tiger plays well, Tiger wins, period. That's just the way it is, and it's never been like that before. It has brought the game to an interesting new stage, I think."

DAVID FEHERTY IN TELEVISION TOWER, 15TH HOLE—THE BYRON NELSON CLASSIC

Shotlink

Jack White

DIRECTOR OF SHOTLINK, BYRON NELSON CLASSIC

Intimately integrated into today's tournament broadcast is ShotLink, the PGA's state-of-the-art electronic scoring and data collecting system.

Jack White, Shotlink's director, says that the idea was conceived three years ago, was in development for two years, and has been in place for a year now.

"Only this year," he explains, "have we gotten to the point where we have a system with a good foundation. We like to joke that NASA at least had the sense to go out into the desert to build a space shuttle, so that if they did have a couple of hiccups, nobody knew it. Well, we built this system right on the launch pad, so we've had a big audience for every hiccup. Everybody's been able to observe our growing pains."

The analogy to NASA is particularly apt when you consider how technically complex Shotlink is.

According to White, "Each walking scorer has a palm [computer] connected by Aria back into our main computers. Say the scorer is following three players. As soon as a player strikes a ball, the scorer punches the 'hit-ball' key, and the palm immediately tells us the ball was struck. We have the exact time every shot was hit. That information comes in and then the palm automatically brings up the next player that's supposed to hit, then the third. That information instantly goes back out to the laser operators that we have set up on certain holes, and when they put the laser on the ball, it gives them the exact distance of the shot and the exact distance into the pin."

On computer monitors like the one in front of White, graphics can show exactly where a player's shot has come to rest. "Lasers give you the coordinates," White explains. And the number of holes equipped with these lasers is steadily growing.

"From six to nine is the first step," says White, and "when we get to where we can manage nine, we'll go up to the next level, twelve. The goal is by the end of the year to have it up to eighteen holes."

This evolution will require advancing electronics, along with an advancing army of volunteers.

Calculating the manpower requirements, White says, "Well, we'll have a walking scorer with every group, and then we'll have two laser operators on every laser." Par-3s only need one laser, and par-5s need three, so you average two lasers per hole, or 36 total lasers and 72 total laser operators."

What's more, says White, the folks in "command central" are also in constant voice communication with every walking scorer.

"That way," he explains, "if we get a report on the screen—a player gets a hole in one, say—we immediately

SHOTLINK TEAM AT THE PLAYERS CHAMPIONSHIP (CLOCKWISE FROM TOP LEFT): LASER OPERATOR MEASURES LENGTH OF DRIVE, 18TH HOLE; LASER GUN & PALM PILOT USED TO RADIO DATA TO CONTROL TRAILER; VOLUNTEER RECORDING SHOT INFORMATION ON PLAYERS HE FOLLOWS FOR THEIR ENTIRE ROUND; CONTROL TRAILER OPERATORS WHO DOWNLOAD INFO FROM FIELD CREWS & FEED IT TO TELEVISION CONTROL ROOM, MEDIA CENTER, & HOSPITALITY AREAS.

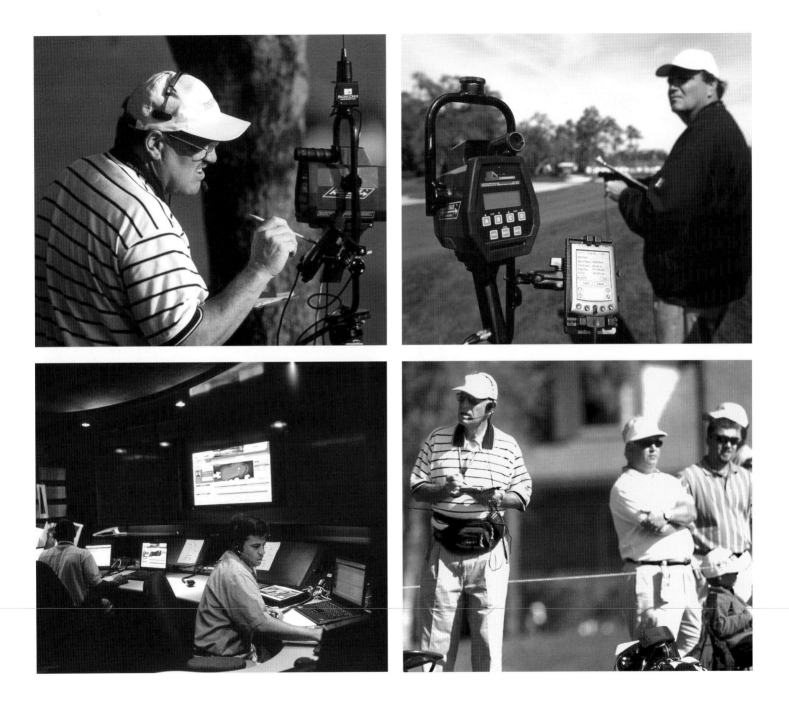

call the walking scorer for instant verification. In the past, if we get a hole in one, we had no way of verifying it. TV really likes that, since they now have instant information that's fully verified. That's been a tremendous improvement."

Needless to say, TV has been quick to capitalize on the information Shotlink makes available. "Look at those graphics on TV," says White. "What's happening there is, they are clicking on hole 14, say, and you can see where all the approach shots have landed on and around the green. And we code it for you so you can see that the blue dots represent all the pars, the black dots are bogies or worse, the red dots are the birdies."

"It was funny. The first response from the media people was 'Okay, it's a lot of stuff, but how do I find the stuff I'm used to seeing . . .'"—Jimmy Gabrielsen

It gets even better. White explains that, sitting at his terminal, he can put his cursor over any one of those colored dots and get a read-out saying whose shot it was, how far he drove the ball, and how long the approach shot was.

No wonder there are 145 computer terminals in the media center, all wired to the central network, and all constantly consuming the millions of bits of data that the Shotlink system is generating. White credits Jimmy Gabrielsen, Shotlink manager, as the man who got Shotlink off the launch pad. Gabrielsen also supervises a permanent staff of 14 and a pool of roughly 200 volunteers.

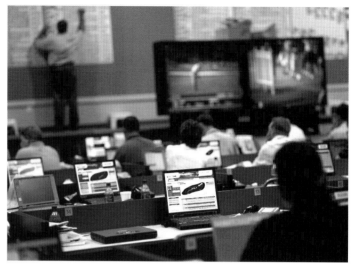

COMPUTERS & SHOTLINK FEED IN MEDIA CENTER—THE PLAYERS CHAMPIONSHIP

In fact, the amount of information instantly available through Shotlink—not just on-course information, but complete stats and bios, even for players not entered in the current tournament—is sometimes overwhelming. The sports media is chewing slowly, trying to digest the whole buffet.

"It was funny," says Gabrielsen. "The first response from the media people was 'Okay, it's a lot of stuff, but how do I find the stuff I'm used to seeing—you know, the leader board, the hole-by-hole, the purse information, things like that.' But now that they have sat down and started to discover everything we've put in there for them, they're like kids in a candy store."

Shotlink's architect smiles and adds, "Yep. I think the office managers of the world are going to hate us, 'cause everybody's going to have this stuff up on their computers instead of what they're supposed to be working on."

CARL WINTER AND HIS WIFE STUDY SCOREBOARD—PHOENIX OPEN

The PGA
TOUR

GIVING THEIR ALL

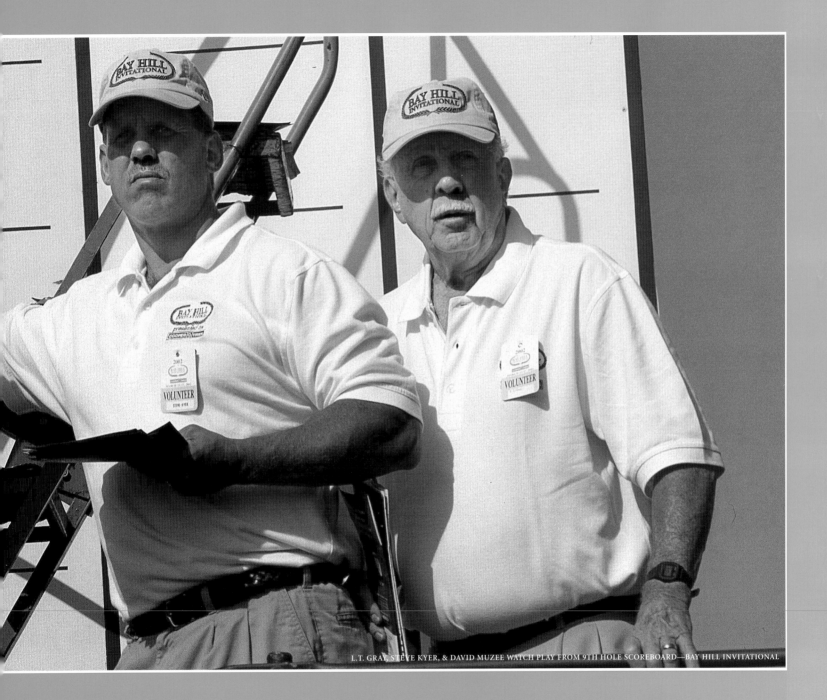

L.T. GRAY, STEVE KYER, & DAVID MUZEE WATCH PLAY FROM 9TH HOLE SCOREBOARD—BAY HILL INVITATIONAL

The Volunteers

Hal Slaton
GENERAL CHAIRMAN, BAY HILL

Long before the equipment and fitness trailers pull into a tournament venue, before the first early-week practice rounds, before the Pro-Am,

HAL SLATON (LEFT) GREETS DAN WIRE, CHAIRMAN OF TREADWAYS CORPORATION
—BAY HILL INVITATIONAL

before the arrival of the myriad media people, hundreds of men and women have already been working.

"Without the volunteers," says Hal Slaton, the General Chairman of the Bay Hill Classic, "I really don't believe you could have the golf tournament."

Slaton, who runs an embroidery and apparel company when he's not running Bay Hill, tries hard to downplay his own role in putting the tournament on. "Essentially, my job is putting together the executive board—the eight so-called lieutenants, each of whom is in charge of a committee. These people are the key, and their committees recruit the people, the volunteers, who do all the hard work. I'm really just an aide and consultant in times of need."

If the numbers—847 volunteers at Bay Hill this year—suggest the prodigious size of the undertaking, Slaton is quick to tip his hat to the high quality of the volunteer corps. "Thankfully, we have a veteran crew of middle-aged and older people who already know what to do. They really don't need a lot of direction." In a sense, he's one of them. He's been helping with the tournament for 13 years.

"There's a 10, a 15, and a 20-year pin, and next year, our 25th year, we'll be giving out some 25-year pins. That's how wonderful these volunteers are."
—Hal Slaton

PAT HOWELL RECEIVES 10-YEAR PIN FROM HAL SLATON, GENERAL CHAIRMAN OF THE TOURNAMENT—BAY HILL INVITATIONAL

In fact, working with "the greatest volunteers in the world" is one of the things that keeps Slaton so enthusiastically involved with the tournament. But even more important, he says, is the charitable contributions that flow from the Bay Hill Classic into the community—especially the millions of dollars that have gone to the Arnold Palmer Hospital. "That's the real reason we're all here," he says. "You ought to see that baby unit. What they do there to save lives is incredible."

Giving his time to the tournament has also meant becoming friends with host Arnold Palmer, which Slaton has found deeply rewarding. "I live at Bay Hill and play at Bay Hill," he says, "and I play with Arnold once in a while. And getting to know him and being part of his life has been a tremendous thrill."

Of course, being tournament chairman should have its perks, and one of them, Slaton admits, is playing in the Pro-Am with the defending champion. For both of Slaton's years as chairman, that partner has been Tiger Woods. "We won it this year," says Slaton, "and Tiger told me it was the first Pro-Am he had ever won. I said, 'You've got to be kidding,' and he says, 'Hey, you're only as good as your partner.' That was a great compliment."

Still, Slaton maintains that the most gratifying part of his job is awarding years-of-service pins to his volunteers. "It's like winning the lottery," he says. "There's a 10, a 15, and a 20-year pin, and next year, our 25th year, we'll be giving out some 25-year pins. That's how wonderful these volunteers are."

Every volunteer gets a pin every year, and the volunteers collect them avidly. "It's a very important part of

ARNOLD PALMER & FANS—BAY HILL INVITATIONAL

how we build these long-lasting relationships, I believe," Slaton says, and it no doubt helps explain why, each year, 90 percent of the volunteers are repeaters.

"Yeah," Slaton confirms, "we don't lose too many. They like it out here, they have fun, and they work hard."

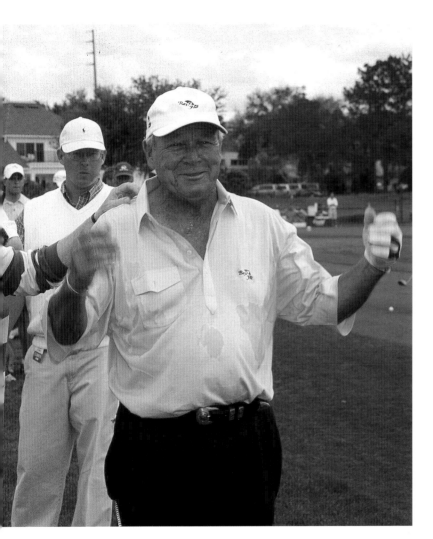

Pat Howell

CO-CHAIR OF TRANSPORTATION, BAY HILL

One of the Bay Hill Volunteers receiving her 10-year pin is Pat Howell, a retired Navy nurse who serves as co-chairman of transportation. Howell started as a driver—getting the players to and from the tournament site—obviously a critical job but one that the volunteers seem especially to enjoy.

Among Howell's favorite memories was the time she was asked to take Fred Couples to his lodgings and then pick him up again in the morning. "So my husband and I got to—had the privilege, I should say—of driving home his absolutely gorgeous Cadillac. And Freddie is just the nicest guy."

Another favorite of Howell's is Dan Forsman. "I have driven both him and his family," she says, "so now when I see him I can ask about his family, which makes it nice." Her husband earned temporary bragging rights, though, when he was assigned to drive his all-time favorite player, Tom Watson, to the airport. "He was in heaven," Howell recalls.

Even though Howell says she enjoyed having the players "held prisoner" in the car, she was careful not to be intrusive. "I didn't start conversations," she says. "I was there to drive them, not to entertain them." Still, many of the players enjoy conversing, says Howell, which gives volunteers a cherished opportunity to know them as people.

What has kept Howell coming back to work the tournament for 10 years? Two reasons: "First of all, it's fun, and, second, the big charitable contribution that the tournament makes." It's simple logic, according to Howell. "The tournament is important to the community, but you couldn't have the tournament without the volunteers."

James Charles
CO-CHAIRMAN

Howell's motive is shared by her co-chairman, James Charles, a retired Navy surgeon and long-time friend of Howell's.

"I think all of us volunteers feel that we are contributing to the Arnold Palmer Hospital for Women and Children," says Charles. "And that's a good feeling."

But there's also the allure of the game itself. "Of course, we are all interested in golf," he adds. "We are interested in meeting the professionals and just seeing them face to face. It's really a unique experience for us."

Charles believes that the people on the transportation committee have it best of all the volunteers. "We probably have the best chance of actually having a relationship with the players," he says. "I mean, look at the marshals. All they do is hold up the signs."

Gordon Shepherdson
DRIVER, BAY HILL

Gordon Shepherdson, a civil engineer, volunteers as one of Pat Howell's drivers at Bay Hill. Like Howell, Shepherdson loves getting to know the players and their families. But that's not his only reason for volunteering.

"You get to play Bay Hill, too," he says, "and that's kind of fun." What's more, Shepherdson says that when things get a little slow, he gets to slip in and watch some of the tournament.

Still, drivers like Shepherdson, who is in his sixth year at Bay Hill, often work long hours. This year he has the afternoon shift, roughly from 1:00 to 7:00. "But if you have someone flying in late," he explains, "of course you volunteer to go pick them up. So with a late run out to the airport, you might end up with a nine-hour day."

Shepherdson enjoyed a special moment this year, when he went to pick up one of the players at the airport, and another guy came along with him, also needing a ride. It turned out to be Tiger Woods' teacher, golf guru Butch Harmon.

"Just a regular guy," says Shepherdson, "a very nice person."

Arthur Lewis
TRANSPORTATION, BAY HILL

Arthur Lewis is another member of Bay Hill's transportation committee who will receive his 10-year pin this year.

"I'm retired," explains Lewis, "and helping out here helps me stay active. I love to get out and meet people. And of course I love golf."

Lewis agrees that being with the professionals on a one-to-one basis is one of the more interesting aspects of the job. Occasionally, he's been surprised at just how forthcoming the players have been. "One of them asked me once if I had any family, and I told him, yes, I had two sons. He said, 'Well, I was wondering, because I'm having a problem with my son, and I need some advice.

What do you think I should I do?' So there we were, talking like a couple of dads about their teenage kids."

Such moments have given Lewis an insight into the lives of golf professionals that not everybody has experienced. "In terms of the basic things like keeping a family and house together," he says, "for these guys, with their constant travel, it must be very, very stressful, very challenging."

Harry Sattlemeier
BAY HILL SECURITY GATES

Harry Sattlemeier, a financial planner during normal hours, has been volunteering at Bay Hill for five years. This year he's at the security gate, letting the authorized vehicles in and out of the restricted parking area.

Sattlemeier says there are lots of good reasons for volunteering, "but the overriding reason," he believes, "is that this is Arnie's place. Palmer is a legend, and this is his tournament, and it's a real thrill to be involved with Arnie and his Army."

Sattlemeier makes the point that volunteering at Bay Hill demands a lot more than just showing up at tournament week. "Meetings started back in September and October," he says. "A lot of time goes into the planning and preparing."

But "making a difference," in Sattlemeier's words, is extremely gratifying. That's why so many people come back to volunteer year after year. "That's the greatest

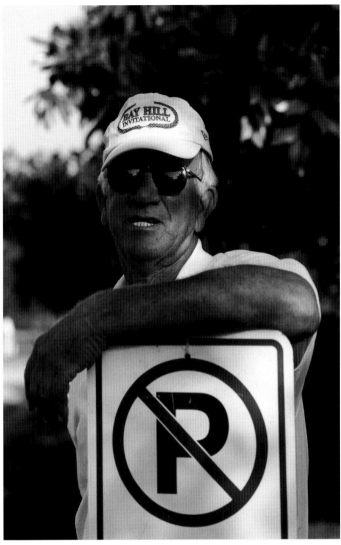

JERRY POWERS HELPS WITH PARKING—BAY HILL INVITATIONAL

thing about it," he says. "You see the same faces and shake the same hands, and after it's over, you can't wait to see 'em again next year."

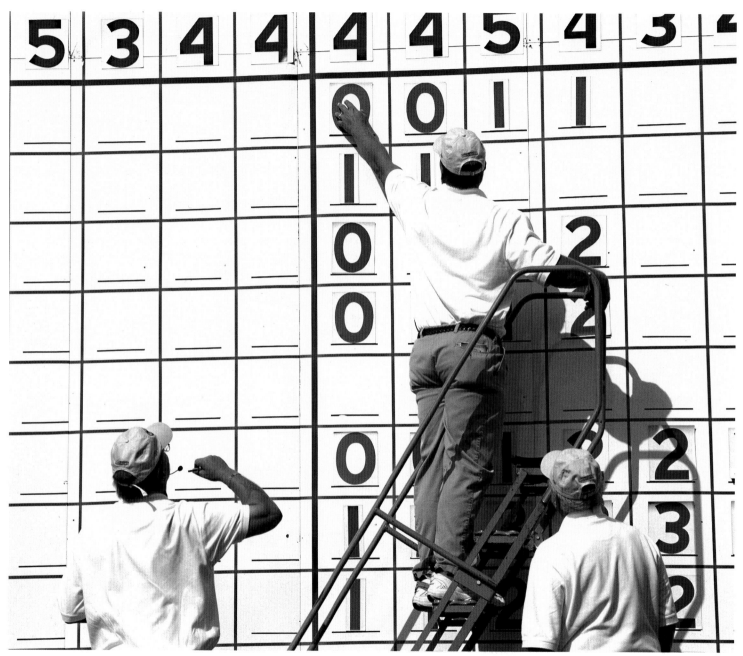

L.T. GRAY, STEVE KYER, & DAVID MUZEE UPDATE SCOREBOARD AT 9TH HOLE—BAY HILL INVITATIONAL

L. T. Gray
STATUS BOARD MANAGEMENT,
BAY HILL

L. T. Gray takes pride in the fact that Bay Hill is one of the last tournaments where the leader boards are kept the old fashioned way—by hand. "Bay Hill, the Memorial, the Masters, maybe one or two others," he says, "but almost all of the tournaments have gone to electronic score keeping. We're the last of a dying breed."

Gray likes the fact that Bay Hill still does it the way it's always been done, and for nine years he's been a fixture at the leader board at No. 9. Now retired, Gray has volunteered at other tournaments as well—"every tournament in central Florida," he says—but Bay Hill is his favorite. "Bay Hill is a classic," he declares.

Gray volunteers for the simplest reason: "I love golf," he says. "I love to be around the people that play the game professionally, and I

"I love golf. I love to be around the people that play the game professionally, and I like to be around the people that enjoy watching those professionals."—L. T. Gray

like to be around the people that enjoy watching those professionals."

And if volunteering cuts into his own playing time, that's okay too. "I tell you, watching these professionals swing the club, you just might improve your own game."

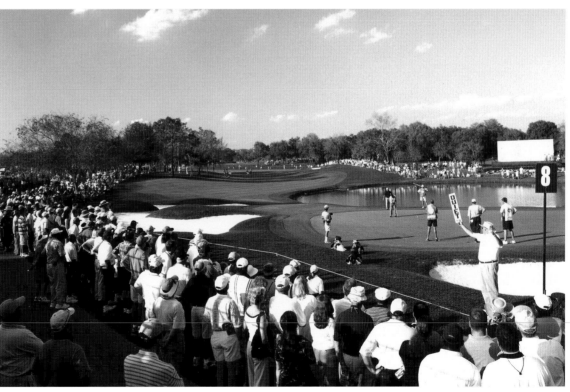

TIGER WOODS MAKES PUTT, NO. 18—BAY HILL INVITATIONAL

Mel Sloan
LOCATOR BOARD VOLUNTEER, BAY HILL

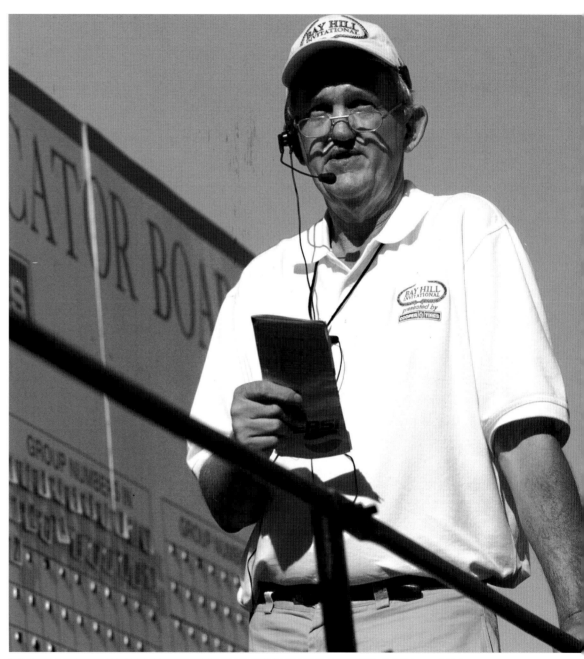

Mel Sloan, whose day job is working on Patriot missiles for Lockheed Martin, is a first-time volunteer at Bay Hill. "I've got friends who have been out here for 15 years," he says, "and I kept asking them if they could find a place for me. This year they finally did, and, Lord willing, I'll be back next year." Sloan shares L. T. Gray's enthusiasm for watching the pros play. In fact, he says that's the best part of the locator board operator's schedule.

"Working the board," he says, "you're only at it for a couple of hours and then you can go look around, follow some of the guys. It's like getting a lesson."

Does it help his game? "Absolutely," says Sloan. "I've dropped maybe ten strokes over the past year."

It may also help that he plays twice a week.

MEL SLOAN & GREG HILLAN MAINTAIN INFORMATION ON LOCATOR BOARD NEAR CLUBHOUSE—BAY HILL INVITATIONAL

Greg Hillan
LOCATOR BOARD VOLUNTEER, BAY HILL

Greg Hillan, working the locator board, is a first-time volunteer at Bay Hill, and he says it's been an experience to remember—in many ways.

"One of the most amazing things," he says, "is the interaction between the players and the crowd. All the players were extremely receptive to the fans. I would say 95 percent of them went the extra mile to meet the people and sign autographs."

Hillan also noticed that the tournament host set an excellent example. "I just couldn't believe the size of the group around Palmer," he exclaims. "And he didn't leave until every single person had an autograph."

In terms of his up-close view of tournament play, what Hillan found remarkable was how well the professionals handle the intense pressure. "I play a lot of golf," he says, "but I just couldn't imagine being out there on the stage, the mental toughness you have to have. A lot of guys are so close, but they just can't get there because of the mental side of it."

But perhaps Hillan's biggest surprise was seeing just what's involved in putting on a golf tournament. "I don't think the average Joe realizes what goes on at these tournaments, and the huge effort it takes from so many volunteers. What goes on behind the scenes is really incredible."

Will Hillan be back next year? "I'm already looking forward to it," he says. "I can't wait to say, 'Hey, I worked the Bay Hill. I was part of the team that pulled it off.'"

Don Naegele
SCOREBOARD VOLUNTEER, BAY HILL

Don Naegele, retired from the Navy, has been working the scoreboards at Bay Hill for 20 years. This year he's on the board at No. 8, and he's enjoying himself. "It's nice when the weather's like this," he says, "because there's been a lot of years where it's been very wet."

One of Naegele's highlights came several years ago when he was working No. 17 and saw one of the players—Tom Kite, he thinks—make a hole in one. But now he's happily ensconced at No. 8. "Eight is a good hole," he says, "because of the water in front of the green. And if they keep the bushes cut down, you can look over and see No. 2."

Naegele says there aren't too many folks still around who started volunteering 20 years ago. "There are a couple," he says, "but when you get to be our age . . . well, you know. On the other hand, there's nothing more fun that seeing the ones who have made it back for another year."

Maureen Brisco
ANOTHER VOLUNTEER ON NO. 8 AT BAY HILL

Maureen Brisco operates the status board—which shows the scores of the players as they come through—beyond the No. 8 green at Bay Hill. There's no mystery as to what has lured her back for a third straight

"I have tremendous respect for Arnie Palmer and what he does for the children's hospital . . . a knight in shining armor of the golf course. If you can help somebody like that, it makes you feel good."
—*Maureen Brisco*

year. "I love the game of golf," she says. "It's wonderful to watch these people."

A true enthusiast, Brisco marvels at the skill of these professionals. "How accurate they are is truly amazing," she declares. "You know, how they can be two hundred yards out, and get it, like, within eight feet of the hole. It's just mind-boggling."

But Brisco says the most amazing thing she has seen was a shot pulled off by Mark O'Meara two years ago. "His second shot went in the water," she recalls, "so he had to sit down, roll up his pants, take his shoes and socks off, and get in the water. When he hit the ball, it went over the spectators' stand and almost into one of the hot dog stands, and he ended up getting a par on the hole."

While enjoying the golf, Brisco also enjoys Bay Hill's charitable endeavors. "I have tremendous respect for Arnie Palmer and what he does for the children's hospital, and he's also a knight in shining armor of the golf course. If you can help somebody like that, it makes you feel good."

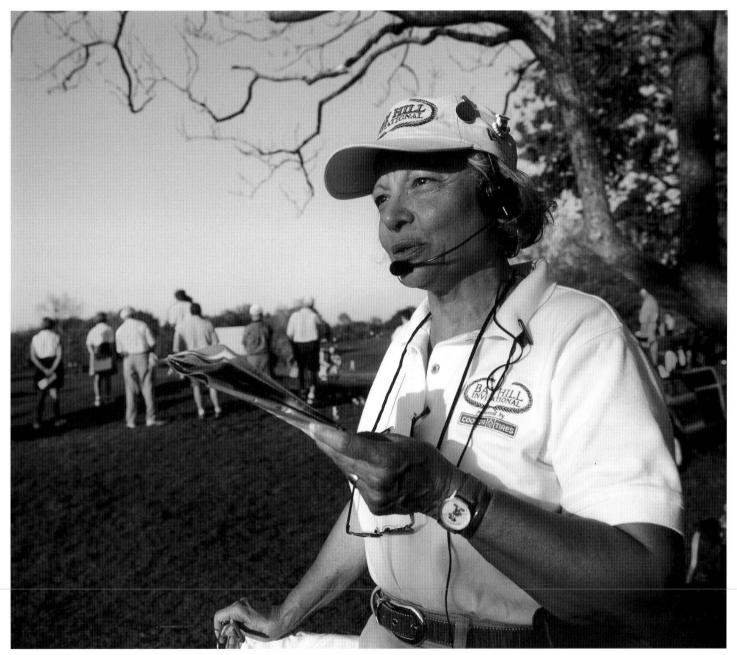

MAUREEN BRISCO RELAYS SCORES AT HOLE NO. 8 TO STATUS BOARD CREW AT HOLE NO. 9—BAY HILL INVITATIONAL

the distance of the shots from the tee. What brings Miller back, he says, is the chance for an up-close view of the players.

"I'm trying to improve," he says, "and just to be able to see these players swing the club is great. Basically it's like ringside seats."

Miller has enjoyed duty on No. 17, the notorious "island hole," and like Greg Hillan, Miller has learned to appreciate the pros' mental fortitude. "It's funny," he says. "You look at that

JEFF MILLER PINPOINTS LOCATION OF DRIVES WITH SHOTLINK LASER, NO. 9 FAIRWAY—THE PLAYERS CHAMPIONSHIP

Jeff Miller
WORKING SHOTLINK PALM PILOT
AT THE PLAYERS CHAMPIONSHIP

Jeff Miller is in his third year as a volunteer at The Players Championship at Sawgrass. This year he's on the No. 9 fairway, using the ShotLink system to record

hole when there's nobody there, it doesn't look that challenging. Just a shot across the water, no big deal. But when you put 40,000 or 50,000 people around there, all yelling, it's amazing how the players can keep their composure. I'd like to see what their pulse rate was standing over that shot."

Miller says he has been able to zoom in on their faces with his laser, and, he says, "their concentration is incredible. Looking at their expressions, it's like the people aren't there."

Miller has no trouble recalling his all-time highlight. He was at No. 17 in 2001. He saw The Putt. "I saw Tiger make that putt from the back of the green, down the hill, breaking about a mile. Talk about a moment—I mean, not only the shot, but the way the crowd just went nuts and, of course, the way he pumps his fist and everything. It was just awesome. I had goosebumps."

If there's one thing Miller has taken from the pros and applied to his own game, it's the concept of recovery. "These guys understand that the bad shots are gone; they're in the past. And they know how to focus on the one that's now. Everybody makes bad shots, but can you recover? You've got to let it go. Move on to the next shot; otherwise it's going to haunt you for the next five or six shots."

JACK KING, MARSHAL, CONVERSES WITH FAN—BAY HILL INVITATIONAL

Jack King
VOLUNTEER FOR PLAYER SECURITY, BAY HILL

Jack King, who has volunteered at Bay Hill for seven years, says that it's the people that bring him back. "On either side of the ropes," says King, "the pros are terrific and the fans are great. It's just a wonderful time."

King's intimate view has brought him to appreciate how enthusiastically the players relate to the fans—especially to the kids. And after four years of working Tiger Woods' detail, he ranks Tiger right up there.

"Tiger is such a delight," says King, ready with an anecdote. "One of the years I was with Tiger, he had been going along really well, but he comes to 10, misses a short putt, and bogeys it. So he's walking off, mad at himself, thumping the ground with his putter, and he walks past this little girl who's about nine years old. Well, this smile from ear to ear comes across his face,

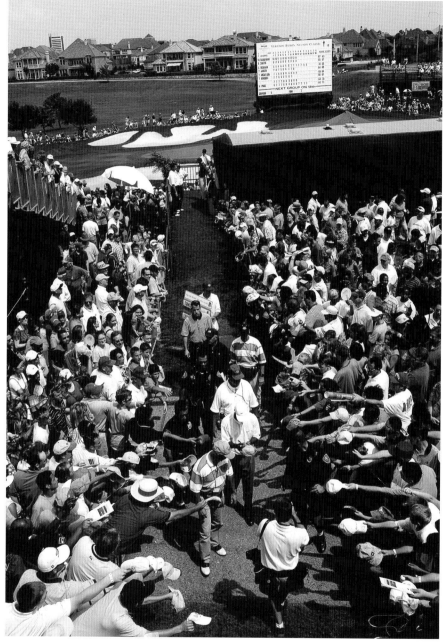

and he hands her the ball. Not many people would have thought to do that, but Tiger always takes the time."

Better than most people, King understands the hysteria that engulfs Woods at every turn. "He comes off of 18, walks through that throng to sign his card, then he's got all the media, and then he comes out and he's swarmed all over again. He always signs as he walks along, but if he stayed and signed everything, he would still be here tomorrow morning when it's time to tee off. I think more people need to understand that."

In fact, King is just as impressed by Tiger the person as he is by Tiger the golfer. "Just think about the pressures that he faces day to day," says King. "I mean, here's a guy who cannot jump in his car and go rent a video at Blockbuster. He can't go out and buy chips and dip to bring home and watch TV. He cannot go to the movies. It's amazing to me how well he deals with these things. He is really, really a great guy."

Take it from a man who walked between the ropes with Woods during the intense pressure of tournament golf: "He's the kinda guy I want to see my daughter bring home, and I don't care if he plays golf. You see what I am saying? He's a very special person."

Ralph Gruber
LONGTIME BAY HILL VOLUNTEER

When Hal Slaton starts handing out the 25-year pins to Bay Hill volunteers, Ralph Gruber will be at the head of the line. "My wife and I have lived here at Bay Hill since 1973," says the retired Army man, "and we know Arnie and his late wife Winnie very well. We helped him start this tournament all those years ago."

As evidence of his long tenure, Gruber recalls "the year of the pantyhose." It was either the first or second year of the tournament, he says, "and the weather turned extremely cold. The golfers

RALPH GRUBER, 9TH FAIRWAY—BAY HILL INVITATIONAL

got so cold that they were having a real problem deciding whether they could continue playing. But I had a little store nearby with a fair supply of pantyhose, and we sold those fellers—Arnie, too, was right there with them—we sold 'em all pantyhose. I even had to go get re-supplies. But it's a fact—they played in those damn pantyhose. They were very effective, too."

Gruber's affection for Palmer has only increased over the years. "He's a real down-to-earth man, a real natural man. He gets aggravated just like the rest of us,"

admits Gruber, "but he never stops reaching out. As a matter of fact, he's playing today, when he does not really want to play. I know that for a fact. But he's not going to disappoint all those people who love to follow him and holler at him and all that sort of stuff."

This old family friend has at least equal respect and admiration for Palmer's lifelong mate: "Let's just say Arnie had an angel riding on his shoulders for many, many years."

WAYNE TENNEY, SALESMANSHIP CLUB VOLUNTEER, CALLS FOR QUIET, HOLE NO. 4—BYRON NELSON CLASSIC

The Players Championship and the Bay Hill Classic are by no means the only tournaments that give generously to charitable organizations. In fact, if putting on golf tournaments is the primary responsibility of the PGA TOUR, raising money for charities runs a close second.

The Verizon Byron Nelson Classic, for another example, is sponsored by an organization called the Salesmanship Club of Dallas, founded in 1920 and dedicated to improving the lives of children and their families. Over the years the Salesmanship Club has raised money through a variety of sporting events, including Dallas Cowboys exhibition games, but for many years now it has concentrated its considerable effort on the golf event it first brought to Dallas in 1944. In 1968, the club renamed the Dallas Open in honor of Byron Nelson, apparently the final ingredient in a formula for remarkable success. Today the Byron Nelson raises more charitable dollars than any other single PGA TOUR event.

How has the Salesmanship Club managed such a stellar achievement? Third-generation member Cullum Thompson—who also served as a vice-chairman of the 2002 Nelson Classic—explains that the club's success is based on the total involvement of every one of its approximately 600 members.

"Honestly, our members put in countless hours. Everything we can find to be donated, is donated. Anybody who can contribute in kind is sought out. Anything we can do to reduce our costs and increase our contribution, we do. It's a huge undertaking."

And that's just to put on the tournament. The club is also involved in the administration of its charity beneficiary, the Salesmanship Club Youth and Family Centers (SCYFC), which now include not only the original Youth Camp, but also an outstanding Family Therapy Program as well as the J. Erik Jonsson Community School, a year-round private school for less-advantaged children.

As Thompson puts it, while the club's membership roster is virtually a "Who's Who" of Dallas business and civic leaders, the basic criterion for membership is "complete willingness to commit yourself and your time to the cause of the organization. You really don't realize when you join this club," he adds, "just what an impact it will have on your life, on all aspects of it."

Tournament week is a highlight, of course. "It's a lot of fun," says Thompson. "Everybody looks forward to it, and everybody takes the week off—even if they're using up their vacation time. Everybody comes down to volunteer at the tournament."

But for Thompson, the real reward comes six months later. "Every Christmas we make a big trip out to the camp in East Texas, take presents for the kids, you know. That's when we get to see the changes that have been made in these kids' lives and their families' lives. Gosh, it makes it all worthwhile, it just really does."

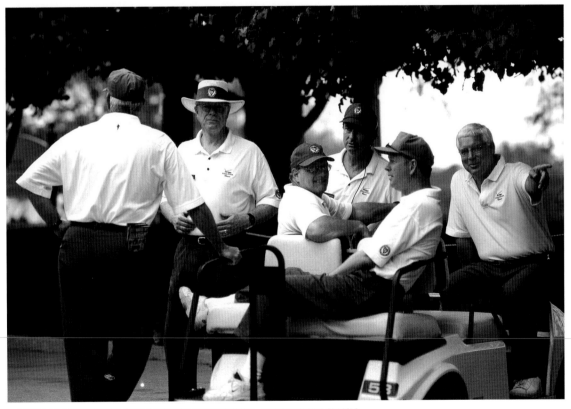

MEMBERS OF SALESMANSHIP CLUB TAKE WELL-EARNED BREAK—BYRON NELSON CLASSIC

The PGA
TOUR

BEHIND THE ROPES

DONALD NORRIS AWAITS BEGINNING OF PLAY AT 1ST TEE—THE MEMORIAL TOURNAMENT

"You don't want to miss the 16th hole. It's famous for the party atmosphere and the enthusiasm of the crowd."
—Richard Svawara

The Fans

Maybe it's the Tiger Woods phenomenon. Maybe it's the fact that older golfers don't retire, and you can still see lifelong favorites like Irwin, Watson, Kite, Nicklaus and even Palmer battling it out on the Senior Tour. Maybe it's because Se Ri Pak has the most beautiful golf swing ever beheld on a golf course.

Whatever the reason, the answer is a definite *yes*—golf's popularity is growing fast enough to make Tim Finchem's head spin.

Richard Svawara
PHOENIX OPEN

Case in point: This year's Phoenix Open, at the Tournament Players Club of Scottsdale, drew 529,210 fans, 100,000 more than the 2001 tournament.

Richard Svawara was one of the half million, and one of the luckier ones holding a pass into a skybox overlooking the 16th hole. With or without the passes, though, he would still be at the Phoenix Open. "I've been here all 12 years that they've held it at this venue," he says.

Indeed, the Phoenix Open may be one of those tournaments where golf is redefining itself as a spectator sport. As Svawara says, even if he weren't in the skybox,

FANS WATCH ACTION FROM GRANDSTAND AT 1ST TEE—PHOENIX OPEN

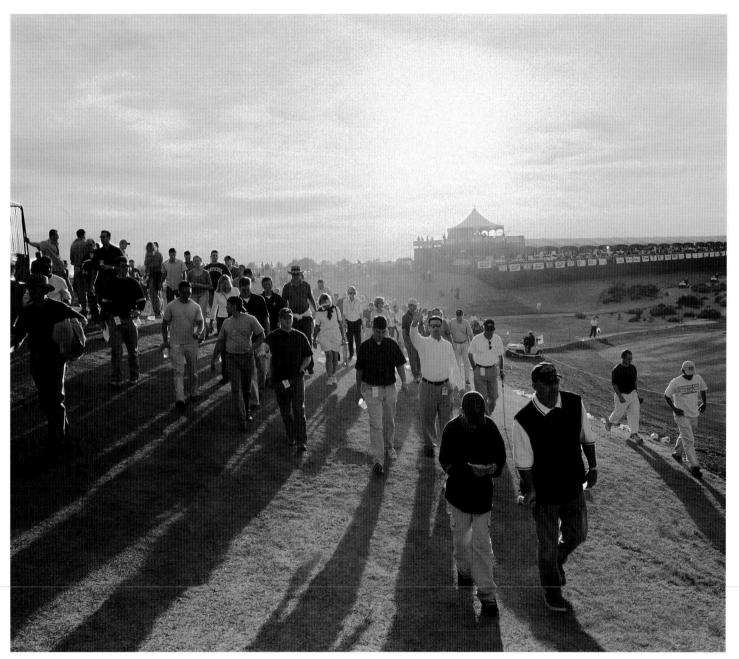

FANS DEPART 16TH HOLE—PHOENIX OPEN

he would be in the crowd at No. 16. "You don't want to miss the 16th hole," says Svawara. "It's famous for the party atmosphere and the enthusiasm of the crowd." Svawara laughs. "By enthusiastic I mean rowdy."

Svawara describes himself as the kind of golfer who spends as much on golf balls as on greens fees, and that's one of the reasons he loves to come watch the pros. "I'm just out here trying to learn," he says. "Maybe some of their skill will transfer over." But in the meantime, let the good times roll.

Phil Giltner
PHOENIX OPEN

Phil Giltner is another Phoenix Open fan fortunate enough to wrangle an invitation into the skybox at No. 16, and he concurs that this place is party central. He points out that if you wander from skybox to skybox you can also see action on 17 and 18, but No. 16, a par-three, is completely in view from tee to green.

And it's rowdy, says Giltner. "When Tiger Woods got his hole-in-one there, fans were actually throwing empty beer cans down on him. It was wild."

Giltner likes being able to stay in one place and watch every group come through. Inevitably memorable events occur.

"This year," he says, "Matt Gogel was in the first group to come through, and when he got up there to hit his tee shot, this little—I don't know—prairie dog or something pops up out of the ground and runs up and

sits down right behind him. Of course, the crowd starts buzzing and laughing, and Matt doesn't know what's going on. Finally he looks around and sees this prairie dog about three feet away just looking up at him, so he pretends to run away like he's scared to death. It was totally hysterical."

Giltner believes these are the special moments for fans, when the players become real people: "I thought it was really neat for a guy in the middle of a tournament to be able to relax and do something charming and funny like that."

Giltner is aware, of course, that the TPC at Scottsdale is one of the so-called stadium courses, designed to bring huge crowds out to the tournament, and he remembers when the Phoenix Open was held at the old Phoenix Country Club. Golf's burgeoning appeal has its costs, he believes. "Back then," he says, "even though Nicklaus won there and Hogan won there, on a big day they were lucky to get 25,000 people in there. That made it intimate and fun in a different way from how it is today. You really could get close to the players."

Not that today's big crowds are likely to be a deterrent to this devoted golfer whose grandfather taught him to play when he was in his early teens. For him, Giltner says, "golf is all-consuming. It's a good thing they have dark at night or I'd be out there all the time." And since

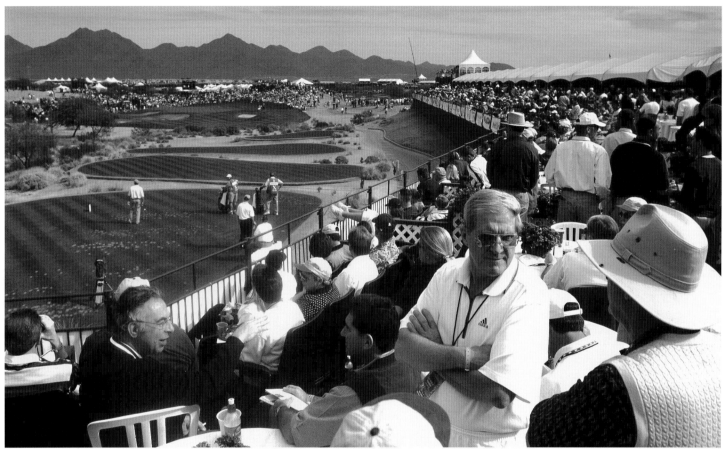

PHIL GILTNER (ON RIGHT WEARING HAT) CONVERSES WITH DAVE LINDNER IN SKYBOX OVERLOOKING 16TH HOLE—PHOENIX OPEN

his wife is his favorite playing partner, his passion for the game isn't going to ruin his marriage.

Like so many fans, Giltner is in awe of the skills that these pros put on display. "The only thing we have in common is that I can stand on the same tee box and walk the same course that they do, " he says, but then another similarity strikes him. "Actually, we also have the same emotions. The difference is, when they have a bad day, it's a 68 instead of a 66."

Then, too, there's that occasional shot you hit just as well as anybody in the world could have hit it. Giltner laughs at a recent memory. "This past weekend I was watching the tournament on TV with a friend of mine, and the leader hits the green on 18, and he's got a three-shot lead. My friend turns to me and says, 'At this point you could win the tournament.' "

Eric Bolduc (with Leigh Basf)
PHOENIX OPEN

Eric Bolduc, in his second year at the Phoenix Open, would rather follow a favorite player around the course than stay in one location and watch them all come through. This year he's been following John Daly.

"There's nothing I like better than being at a hole when something spectacular happens, feeling that adrenaline rush, sharing it with the player. That's when fans feel at one with the game, and it's very exciting."—Eric Bolduc

"Daly is great with the fans," says Bolduc. "He's really friendly, and, of course, he has that awesome power." There's also Daly's considerable "common man" appeal. "He's had his trials and tribulations, his vices and struggles, and it makes you want to rally behind him. The way he's moved forward and really worked hard on his game is great to see."

Bolduc hates it when Daly suffers one of his "meltdowns" on the course, when he scores one of those dreaded "others," but in a way those only heighten the man's appeal. As Bolduc explains, "Part of you says, 'Well, he's just like me.' Of course, I have more meltdowns than Daly does."

ERIC BOLDUC & LEIGH BASF CHEER JOHN DALY AT 18TH HOLE—PHOENIX OPEN

An avid golfer whose driving ambition is to play the top 100 courses in the country before he dies, Bolduc loves the up-close view of how the pros do it. "It's amazing to see it first-hand," he says. "And it makes you realize that Tiger Woods is not the only great player out there."

As a self-proclaimed traditionalist, though, Bolduc has mixed feelings about the boisterous atmosphere in the stadium at No. 16. "Don't get me wrong," he says. "There's nothing I like better than being at a hole when something spectacular happens, feeling that adrenaline rush, sharing it with the player. That's when fans feel at one with the game, and it's very exciting."

But he's leery of rowdy fans new to the sport, who seem to have no respect for its traditional decorum. "Like yelling out during a player's backswing," he says, "I mean, there's no room for that. Okay maybe for football or basketball fans, but this is a different sport."

YOUNG FAN FOLLOWS ACTION FROM TREE OVERLOOKING HOLE NO. 1—BYRON NELSON CLASSIC

Blake Houseman (and Bill Houseman)
BYRON NELSON CLASSIC

As they do every year, Blake and Bill Houseman arrived early and took up residence beside the No. 1 green at the Byron Nelson Classic.

"I've got a bad knee," says Blake, "and can't walk the course. So we make it this far, and then I sit down and watch the boys come through. That's it—we never move." Not that he's complaining. "It's the perfect spot," he says.

"We were sitting here and Tiger drove it all the way through the green. They measured it off at like 408 yards . . . he just killed it."—Blake Houseman

No. 1 is a short par-four, so the two brothers have seen some fantastic approach shots over the years. "Never seen anybody knock it in," says Blake, "but yesterday, for example, two guys in the same threesome, got within a foot of the pin. That was pretty good stuff."

No question, though, as to the most amazing shot they've seen from their greenside perch. "I guess it was a couple of years ago," says Blake, "we were sitting here and Tiger drove it all the way through the green. They measured it off at like 408 yards." He and his brother shake their heads, still not believing. "I mean," says Blake, "he just killed it."

LT. GENERAL WILLIAM O'CALLAGHAN WATCHES PLAY AT 15TH GREEN
—THE PLAYERS CHAMPIONSHIP

Sean Connellan (with Lt. Gen. William O'Callaghan)
THE PLAYERS CHAMPIONSHIP

Sean Connellan is a serious golf fan, but his fervor pales in comparison to that of his 81-year-old father-in-law, Lt. Gen. William O'Callaghan.

Their annual "pilgrimages" began in 1989, says Connellan, when O'Callaghan came over from his home in Dublin, Ireland, to visit his daughter and son-in-law

"Bill is a student of the game. Just loves golf, and has played it for more than 50 years. So this is just a fun thing for us to do together."—Sean Connellan

in Rochester. "The U.S. Open was in Rochester that year," explains Connellan, "at Oak Hill. That was our first major, and we've been to all but three Opens since then."

Not to mention a few Masters, a couple of PGA Championships, a Ryder Cup or two, and, for the last 10 years, all The Players Championships at Sawgrass.

"Bill is a student of the game," says Connellan of his father-in-law. "Just loves golf, and has played it for more than 50 years. So this is just a fun thing for us to do together."

O'Callaghan makes the trans-Atlantic journey every year, says Connellan. Twice. He flies to the Connellans' home in Rochester in mid-January, goes back to Dublin in May, returns to visit at Connellan's home in Florida for a couple of months during the fall, then flies back to Dublin in early December. "He'll be ready to start the cycle all over again next January," says Connellan.

Between his father-in-law's expertise and all the tournaments he's watched first-hand, Connellan's own game is steadily improving. Right? "Well," Connellan says, "seeing and doing are two different stories, you know?"

Scottie Wylie, with kids Casey and Thomas
THE PLAYERS CHAMPIONSHIP

Scottie Wylie and his wife Christine go to The Players Championship every year, but this year, for the first time, they took eight-year-old daughter Casey and six-year-old son Thomas out during the practice rounds to do some autograph hunting. "Once we got them there," says Wylie, "they stayed all day."

Wylie says they took the children back for one day of the actual tournament, "but they never saw a minute of the golf. They were having too much fun."

CASEY & THOMAS WYLIE SEEK AUTOGRAPHS NEAR CLUBHOUSE
—THE PLAYERS CHAMPIONSHIP

FAN STEADIES HIS BINOCULARS—U.S. OPEN CHAMPIONSHIP

Wylie figures the kids got about eighty autographs in all, including the ones on their caps and on the glove and the couple of balls that they also came up with. "They had an absolute ball," he says.

They never got Tiger's autograph—"He's a little hard to get at," says Wylie—but that's okay. Casey's got her own favorite: Justin Leonard. "She had her picture in the local paper getting an autograph from him, so he's the one she gets excited about."

All in all, the experience makes Wylie appreciate the tournament's "kid-friendly" policy during the practice rounds. "They let the children in free before the actual tournament starts," he says, "which is really a nice gesture."

A Ponte Vedra resident, Wylie has played the Stadium Course a few times. "But you can't play it too often," he says, "'cause it kills you so bad."

Don Jessup
THE PLAYERS CHAMPIONSHIP

No problem picking Don Jessup out of the crowd at a golf tournament. He's the guy wearing the green on top of his head. (Okay, it's a hat that looks like a green, with a golf ball on the fringe and a pin sticking up out of the middle.)

Jessup dates his strange obsession from about 10 years ago, when he bought a hat that looked like a peacock at Spencer's gift shop. A friend of his had also bought a goofy hat, and the two of them found themselves together at the World of Golf at Pinehurst. "People started laughing at us," says Jessup, "and I decided that if you're going to get attention, this was better than robbing banks. I've been wearing funny hats ever since."

His collection now runs to close to 200 hats, but it's still growing. He says he's bought so many from one particular store that he's now considered a wholesale customer.

Golf courses are not the only beneficiaries of Jessup's fashion fetish. "I wear them around the neighborhood when my wife and I take our morning walk. I try to wear a different one every day. Fortunately," he adds, "my wife is impossible to embarrass."

But the golf green hat is one of his favorites. "Interesting story," Jessup begins. "When my daughter got married, we hosted a golf game for the wedding party. I bought 36 of these hats, with the flag and the ball on top, and I told all the guests who came out to play golf that if they wore the hat I would give it to them. You

know, everybody had said how much they loved the hat, how much they wanted one, but nobody would wear it. I think I gave away three hats."

The hats are just a way to have fun, says Jessup. "And a big part of it is watching the kids laugh. When you see the kids laugh, it's well worth it."

Needless to say, not everybody thinks it's funny. "I went to the practice rounds at the Masters this year," recounts Jessup, "had my hat on, my Astroturf vest with golf balls buttons, my knickers, and they told me I couldn't wear it. They escorted me out."

Jessup has never had a problem anywhere else, though. In fact, he believes he's on to something. "I have a giant flamingo hat," he says. "I call it my 'dare' hat. I've told lots of single guys that if they want to pick up girls, wear this hat. They always say no, no, they won't do something like that. Then I'll put the hat on, and invariably the women come over to tell me how much they like it. The single guys just don't see what an opportunity they're missing."

FATHER & SON—PHOENIX OPEN

". . . a big part of it is watching the kids laugh. When you see the kids laugh, it's well worth it."—Don Jessup

Beth and Steve Libby (wife and husband)
THE PLAYERS CHAMPIONSHIP

"It's the only game I've ever played that never got boring," —Steve Libby

You can work at being a golf fan if you want to. Steve and Beth Libby decided to sit down on the job. They unfolded their chairs on No. 7 at Sawgrass, Steve lit his cigar, and they watched the tournament flow past like a slow-moving river.

It was a first for Beth, who had never seen a tournament in person, and a thoroughly enjoyable experience. "I was fascinated," she says. "I couldn't believe how quiet the crowd got when the players hit the ball. It was just a very peaceful day for us, and a beautiful golf course, I thought."

With a husband who plays golf three times a week, Beth describes herself as a golf widow—but not a resentful one. "It gives him great joy," she says, "so I don't mind. Besides, I have my own little interests."

She may have found a new one. "It really was nice to be out there and get to see some of the players up close and personal. That was kind of exciting, too, after seeing them on TV."

For husband Steve, the experience was not quite so novel. He makes it to most of the tournaments that come his way—the Bay Hill Classic, the National Car Rental Classic at Disney, and The Players Championship—every year.

But watching or playing, the fascination never diminishes. "It always amazes me," says Steve, "how smooth they swing and how strategically they play." He mentions seeing Tom Kite on No. 7—how he drove it into the rough, then decided to lay up. "But his lay-up landed in the rough, too, and I was thinking, 'What a dumb shot.' But then he hits a 100-yard wedge to about two feet from the hole and makes par."

The lesson there? "You've got to learn how to take what the course gives you," says Steve.

He has played since high school, even worked at a club for a couple of years during his 20s, dreamed of playing competitively. He still loves the game passionately.

"It's the only game I've ever played that never got boring," Steve explains. "Everything else, the luster eventually wears off. But golf is always a challenge—self-discipline, playing within yourself, exerting your will, all of that. It's just a wonderful game."

BETH & STEVE LIBBY ENJOY THE COMPETITION AT 7TH HOLE—THE PLAYERS CHAMPIONSHIP

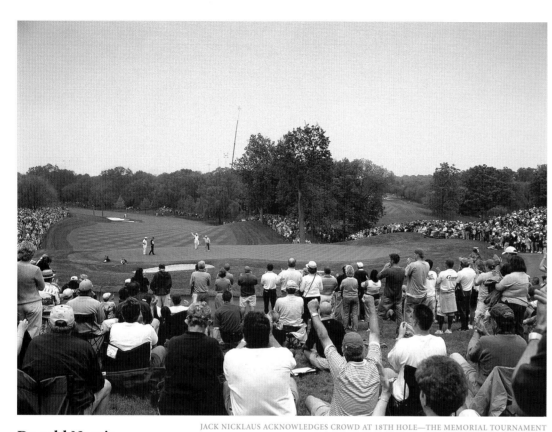

JACK NICKLAUS ACKNOWLEDGES CROWD AT 18TH HOLE—THE MEMORIAL TOURNAMENT

Donald Norris
AT FIRST TEE, BEFORE START OF MEMORIAL

Donald Norris got up with the chickens, brought his chair, and roosted beside the No. 1 tee at the Memorial. He wasn't just the first fan there. He was there before the marshals.

"I know how crowded it gets there," he says. "I like to beat the traffic." Besides, after attending the practice rounds for several years, this was the first time he had landed a ticket for the real event, and he wasn't going to blow it.

But make no mistake. Norris doesn't stay parked at No. 1 all day. There's a particular player he likes to follow.

"I enjoy following Nicklaus around," he explains. "Some of my family members knew his parents when they ran that drugstore up in the North End, so I've been following him ever since I was about 18, when I first got into golf."

Illness has forced Norris to give up playing, but having played the game— having had that experience— has made him an avid fan for life. "I miss very few tournaments on TV," he says.

His one regret is that Nicklaus is in so few of them these days. "No question—he was the Tiger Woods of his day," says Morris, "but now, it's like he says, 'Everything's getting older.' You know, he just doesn't play the caliber of golf that he would like to, to really compete."

Morris says he'll only return to the Memorial next year if Nicklaus enters, which is a wait-and-see proposition.

"But the good news is," he says with a smile, "he made the cut this year, and he hasn't done that in a while."

CHAIRS HOLD PRIME SPOTS OVERNIGHT FOR FANS AT 9TH GREEN—BAY HILL INVITATIONAL

The PGA
TOUR
THE GOLFING LIFE

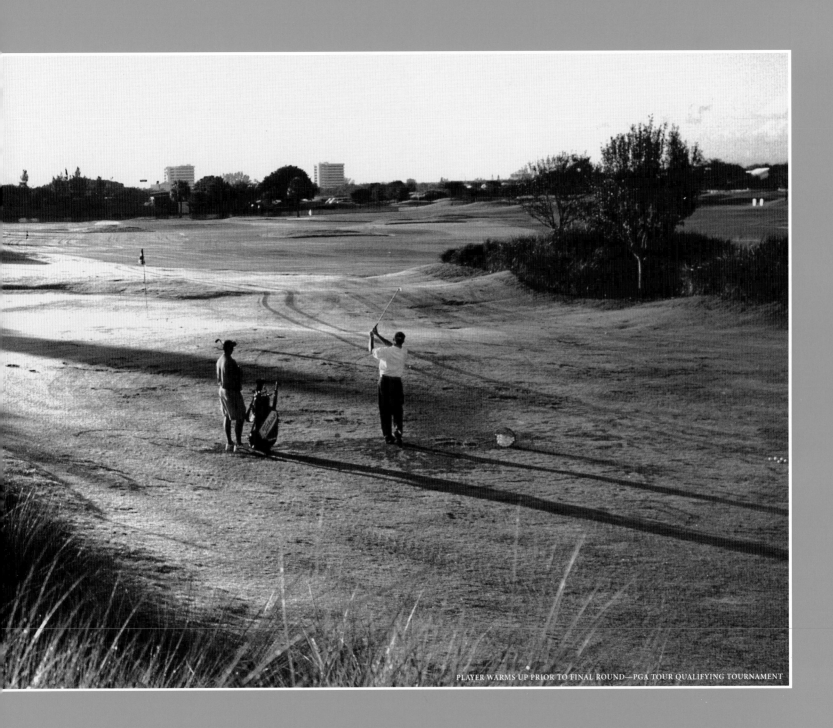

PLAYER WARMS UP PRIOR TO FINAL ROUND—PGA TOUR QUALIFYING TOURNAMENT

Earning the Privilege

Call it Q-School, or call it fourteen rounds of hell. It's the three-stage PGA National Qualifying Tournament that winnows more than 1,000 aspirants down to the 35 who "earn their card"—i.e. who will enjoy full playing privileges on the PGA TOUR for the following year.

For the following year only. To keep their card, players must finish that year in the top 125 on the money list. Finish 126th or lower, and it's back to school.

Consider Brad Elder, who had been on the TOUR for two years but finished the 2001 season ranked No. 128.

Back in Q-School in December, Elder survived the first two stages to make it to the finals. Perhaps feeling the pressure of what these guys generally consider the toughest tournament in the world, Elder began the final round by hitting two drives out of bounds on No. 1 for a triple bogey. Somehow he regrouped, shot a 69, and retained his card for the 2002 season.

Elder may need another dose of fortitude, though. After a fast 2002 start, finishing 13th at the Sony Open in Hawaii in January, he has missed twelve cuts in twenty events, and his earnings for the year stand at $144,024. The school bell is ringing.

PLAYERS ROLL PUTTS PRIOR TO FINAL ROUND—PGA TOUR QUALIFYING TOURNAMENT

BRAD ELDER PREPARING FOR FIRST DRIVE OF FINAL ROUND—PGA TOUR QUALIFYING TOURNAMENT

DOUG BARRON MISSING PUTT HOLE NO. 17—PGA TOUR QUALIFYING TOURNAMENT

Or Doug Barron, who finished 3rd at Q-School in 1996 to earn his TOUR card for '97 and held on to it for five years. But Barron struggled through an injury-plagued 2001 season and forfeited his card, then finished 37th at Q-School—missing the top 35 by one stroke. This missed birdie putt on No. 17 at Bear Lakes County Club in West Palm Beach, Florida, tells the agonizing story.

Barron was given a so-called "minor medical extension" for 2002, allowing him five events to earn $328,515 (which, added to his 2001 earnings of $77,837, would equal No. 125 Woody Austin's 2001 total of $406,352).

Though he failed to reach that unlikely goal, Barron has had a stellar year on the BUY.COM Tour, finishing 2nd four times and 3rd twice. As the 2002 season was winding down, he stood 3rd on the money list, virtually assuring full-exempt status on the big TOUR in 2003.

Then there's 38-year-old Pete Jordan, who first joined the TOUR in 1994 after finishing tied for 4th at the 1993 Q-School. He held on to his privileges until 1998, when he finished 147th on the money list, but at season's end he finished 5th at Q-School to return for the '99 TOUR season. He finished 135th in '99—ten spots below exemption—but scored a 15th place at Q-School and was back for 2000. His $464,480 in earnings that year kept him in the top 125 and out of school for a year.

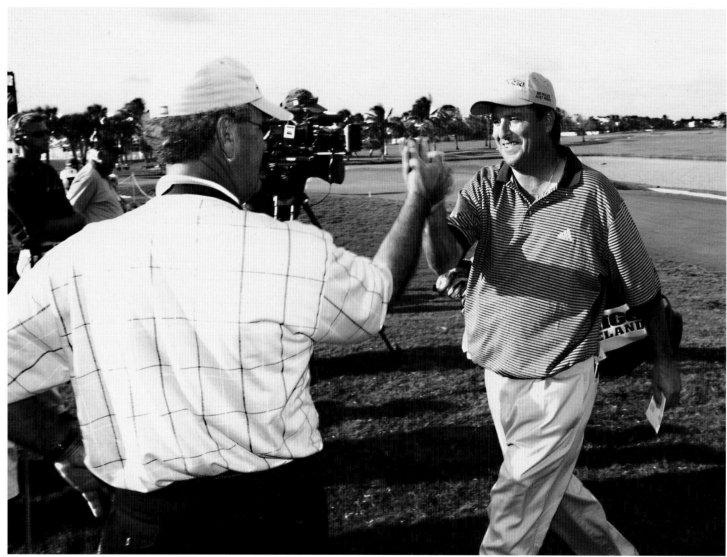

PETE JORDAN ACCEPTING CONGRATULATIONS, HOLE NO. 18—PGA TOUR QUALIFYING TOURNAMENT

But despite 36 starts in 2001 (tying for most tournaments played), Jordan's earnings fell to $386,088, and his ranking to 130. Undaunted, Jordan enrolled in school at the end of the season and finished tied for 2nd. He was back for "the big show" again in 2002.

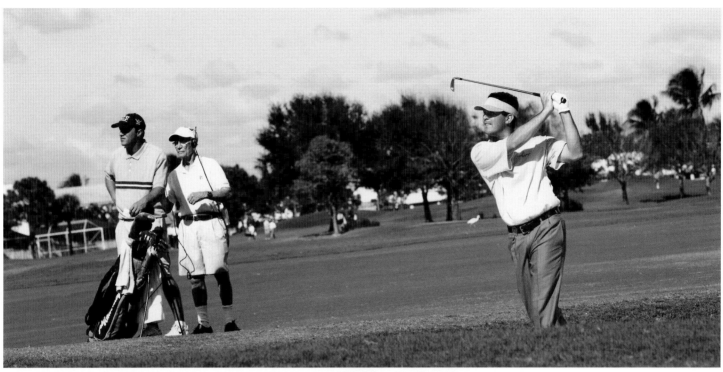

BRAD ADAMONIS WATCHES BUNKER SHOT FLY TO GREEN, HOLE NO. 18—PGA TOUR QUALIFYING TOURNAMENT

CADDY CONSOLES ANTHONY RODRIQUEZ AT HOLE NO. 18—PGA TOUR QUALIFYING TOURNAMENT

Needless to say, with more than 1,000 players matriculating at Q-School every year, and only 35 (plus ties) graduating to the PGA TOUR, heartaches are plentiful. Brad Adamonis and Anthony Rodriguez both failed to qualify, but both played well enough to win a valuable consolation prize: exempt status on the BUY.COM Tour, where competition is keen, prize money is plentiful, and dreams are very much alive.

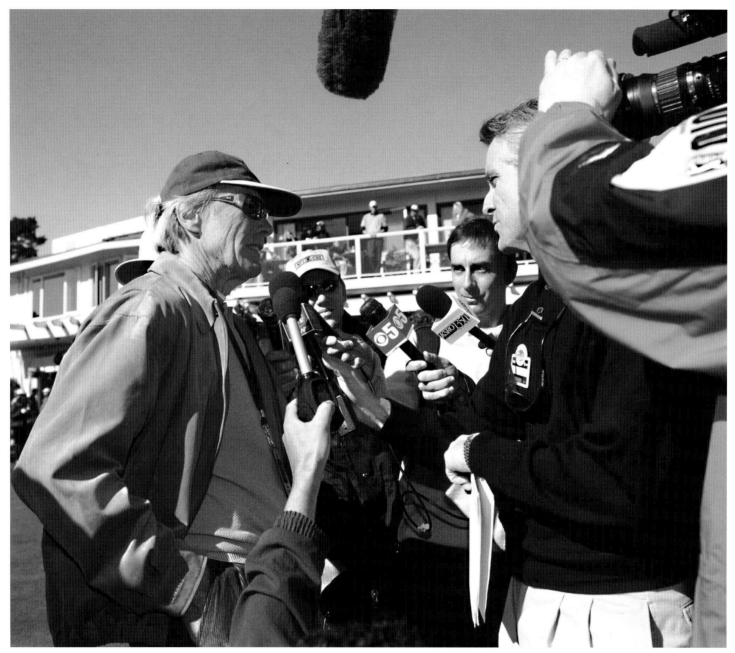

CLINT EASTWOOD RESPONDS TO REPORTERS—AT&T PEBBLE BEACH NATIONAL PRO-AM

How Sweet It Is!

For players who do qualify, life on the PGA TOUR must look pretty good as the new year dawns. January offers two events in the warm luxury of Hawaii, and before the month is over, the TOUR lands on the spectacular Monterey Peninsula, home of the AT&T Pebble Beach National Pro-Am.

Begun as Bing Crosby's "clambake" in 1937, and still called simply "the Crosby" until 1985, the event moved to Pebble Beach in 1947 and still remains the tournament where the stars come out during the day. Clint Eastwood, chairman of the Monterey Peninsula Foundation, is a perennial marquee attraction, and he leads a large contingent of Hollywood's brightest. Bill Murray, he of the goofy hats and exploding golf balls, picked up the torch upon the demise of crowd-favorite Jack Lemmon and has become one of the most visible, and entertaining, stars of the event. Here pro golfers rub elbows with screen legends like Kevin Costner

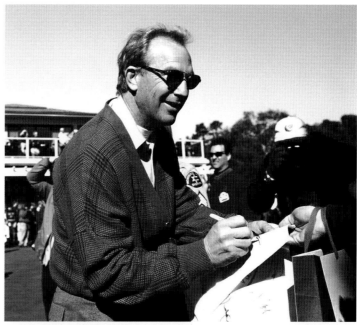

KEVIN COSTNER SIGNS AUTOGRAPHS—AT&T PEBBLE BEACH NATIONAL PRO-AM

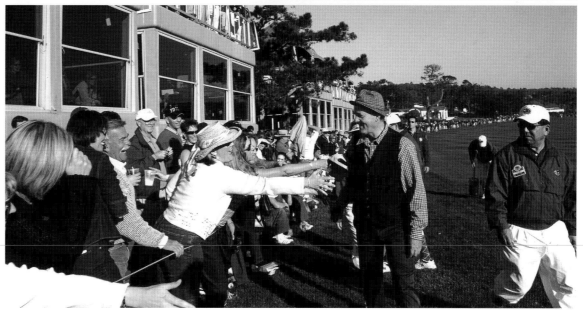

BILL MURRAY GREETS FANS LINING 18TH FAIRWAY—AT&T PEBBLE BEACH NATIONAL PRO-AM

C. MICHAEL ARMSTRONG ROLLS PUTT AT HOLE NO. 8—AT&T PEBBLE BEACH NATIONAL PRO-AM

and recording artists like Clay Walker—not to mention top-echelon athletes from other major sports.

High chieftains from the corporate world also make the scene, including CEO Mike Armstrong of title sponsor AT&T, participating sponsor Charles Schwab and George Roberts, founding partner of Kohlberg Kravis Roberts. Both Schwab and Roberts are members of the Senior PGA TOUR Division Board.

If the golf pros feel that their luster is dimmed in the company of such exalted celebrities, think how the Hollywood types must feel having to tee it up next to

GEORGE ROBERTS CONFERS WITH CADDY HOLE NO. 9—AT&T PEBBLE BEACH NATIONAL PRO-AM

CHARLES SCHWAB HITS DRIVE HOLE NO. 9—AT&T PEBBLE BEACH NATIONAL PRO-AM

KEVIN COSTNER, CLAY WALKER, & BILL MURRAY CHAT PRIOR TO TEEING OFF AT 1ST HOLE—
AT&T PEBBLE BEACH NATIONAL PRO-AM

119

Woods, Mickelson, and the like. Here's how actor Chris O'Donnell describes the experience: "First time I teed it up at Pebble, I was in a group that was sandwiched between Tiger and Duval on one side and the Golden Bear and Bill Murray on the other, so the fairways were lined tee to green about three people deep. I was so nervous that my hands were shaking to the point I didn't think I could hold onto the club." And this is from a guy who says his father and older brothers had him playing golf by the time he was five years old.

The week features a virtual barrage of pre-tournament events, including the Avaya Pro Shoot-out, the 3M Celebrity Challenge, the Payne Stewart Youth Clinic, and a laugh-filled Celebrity Roast. All fun and all in a good cause: the AT&T Pebble Beach National Pro-Am raises more than $4 million each year for 150 benefiting charities throughout Monterey County.

The tournament itself, with its fabulous vistas of Monterey Bay, is always a favorite of the players and always draws a strong field. Who would take home the trophy—and the

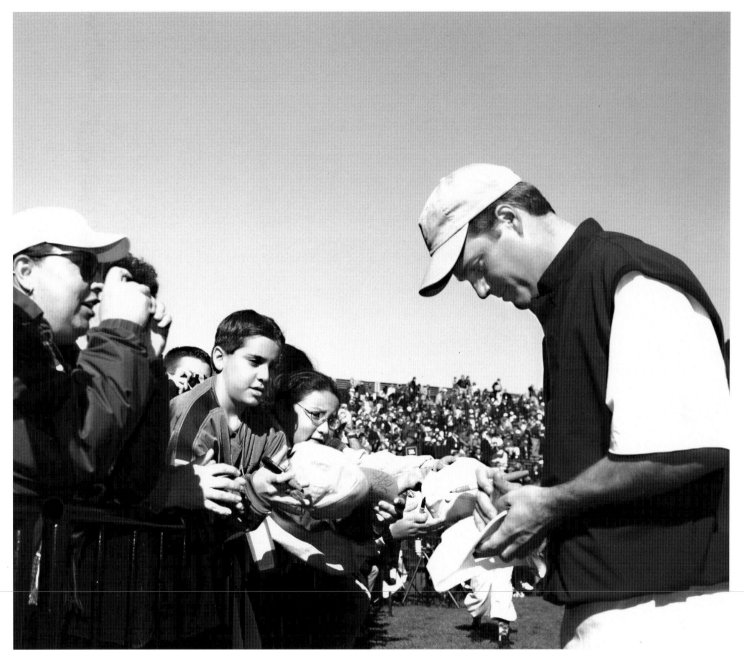

CHRIS O'DONNELL SIGNS AUTOGRAPHS, 18TH HOLE—AT&T PEBBLE BEACH NATIONAL PRO-AM

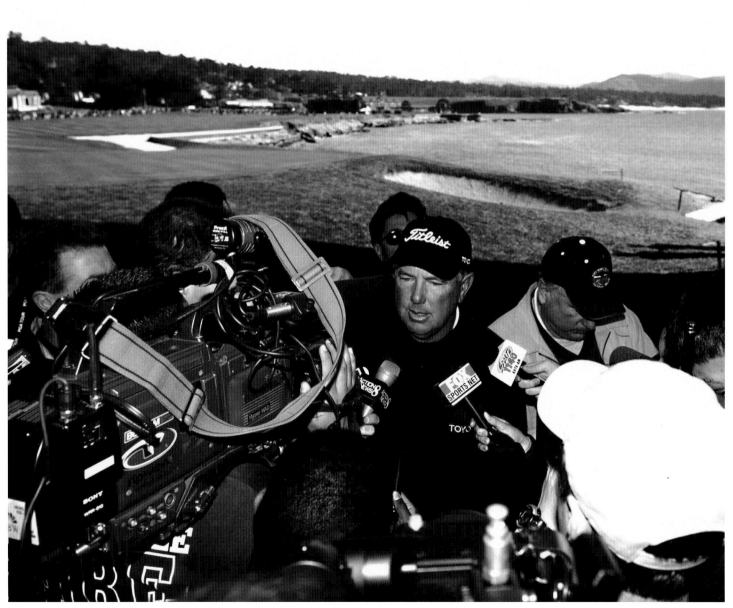

MARK O'MEARA RESPONDS TO REPORTERS AFTER COMPLETING ROUND—AT&T PEBBLE BEACH NATIONAL PRO-AM

FREDDIE COUPLES EXPRESSES DISMAY AT 18TH HOLE—AT&T PEBBLE BEACH NATIONAL PRO-AM

$720,000 winner's check—in 2002? Well, it wasn't five-time champion Mark O'Meara. With opening rounds of 75-69-73 in this five-round event, O'Meara missed the cut by one stroke. Ever-popular, sweet-swinging Freddie Couples fared better. In fact, his 22nd-place finish was one of several solid showings for Couples in what would prove to be a comeback year. Unfortunately, Couples' playing partner Davis Love would end up joining O'Meara on the sidelines after the first three rounds.

Surprisingly, thanks to a collapse by Pat Perez on the tournament's final hole—a triple bogey that featured a shot into the bay—the championship went to Matt Gogel, his first PGA TOUR victory. A stalwart on the BUY.COM Tour before joining the regular TOUR in 2000, Gogel's days at Q-School are a distant memory.

All in the Family

Tabitha Furyk
WIFE OF JIM FURYK

The television cameras sometimes offer fans a glimpse of Tiger's girlfriend, or Sergio's, and Phil Mickelson usually gets a kiss from wife Amy on his way to the winner's circle. The fact is, though—despite the absence of diapers on golf telecasts—most TOUR players are family men. And many of their families are growing.

Among the "TOUR babies" to arrive during the 2002 season was Caleigh Lynn Furyk, daughter of Jim and Tabitha.

A month before the baby's arrival, Furyk did his job by providing a handsome nest egg. With Tabitha on hand to watch, husband and daddy-to-be won the Memorial at Muirfield—and took home the prize money of $846,000.

It was probably more excitement than a close-to-term mother really needed. Furyk was five strokes down when the final round began, and when he made the turn, twelve players were within two strokes of the lead. It must have suddenly occurred to Furyk that in 18 short years, he was going to have to start paying college tuition. In any case, he made a back-nine move with a chip in for birdie and a holed bunker shot for eagle and left the field behind.

"I started looking up at the leaderboard," said Furyk, "and realized it was a close race." In a jiffy, he moved from one down to three up. "It was pretty exciting."

Providing for the additional family member aside, Furyk may have taken extra incentive from the fact of ending Tiger Woods' three-year reign at the Memorial. A year earlier, at the World Golf Championships NEC Invitational, he had lost to Tiger in a dramatic seven-hole playoff.

Of course, nobody goes broke finishing second in PGA TOUR events, but for the record, Furyk's Memorial win was his seventh on TOUR. And with his more than $2 million in 2002 earnings, Tabitha and Caleigh Lynn don't need to worry about anybody taking Furyk's TOUR card away.

But for Caleigh Lynn's first birthday: Come on, Dad. How about a first major championship?

TABITHA & JIM FURYK DURING BRIEF EXCHANGE BEFORE AWARDS CEREMONY—THE MEMORIAL TOURNAMENT

Molly Damron
WIFE OF ROBERT DAMRON

Robert Damron is in his sixth season on TOUR. His wife, Molly, quit her job in medical sales to begin traveling with Damron at the beginning of the 2001 season. She's still making the adjustment.

"For Robert it's normal now, but for me it's still pretty new—living out of a suitcase and being in a new city every week." The couple do what they can to make away-from-home seem like home. "Robert likes to go to the same hotels in each city, and we do very normal things—go to the local restaurants, come back in and watch TV. We just kinda do our own thing."

Of course, they see the same friends every week. "Since I've stopped working I've met everybody, and everybody is really nice, and it's like a family out there. You see your friends every week, sometimes you stay in the same hotels."

But Molly's life on the road is about to get complicated. Like Tabitha Furyk, she's due to have a baby before the 2002 season is over. As soon as convenient, though, she'll resume traveling. "The TOUR makes it so easy," she says. "Well, as easy as it can be for families. They have day care every single week, and they have the same girls week after week." The girls get to know the children, Molly explains, and the children all get to know each other. "That way, you can really feel confident leaving your kid."

Still, Molly expects it to be difficult. "I don't know how some of these people do it with, like, four kids—plus all the luggage and toys. There is definitely an art to it, so I

think I'll learn. By trial and error, maybe, but I will learn."

Harder than the travel, though, is the tournament itself—following the player/husband, dealing with inevitable frustrations, the blown shots, the near-misses, the lip-outs. "I used to be so nervous," says Molly. "Finally I told him how upset it made me and he said, 'Why are you nervous? I'm not nervous. It doesn't bother me so it shouldn't bother you.' That really helped me, and watching him hasn't bothered me so much since."

With one exception: the 2001 Byron Nelson, Damron's lone TOUR victory, which he won with a birdie on the fourth hole of sudden death. "Actually," says Molly, "I couldn't be with him that week. I was watching on TV, and it was absolutely excruciating."

Damron has had a slow season and a half since that victory, and Molly's take is that after six years of the travel and the grind, "he was just getting kind of tired." Now, though, says Molly, "he's starting to get hungry again, really excited again, which is great to see."

For the TOUR wife, his dream has got to be her dream. "That's all I care about," says Molly, "that he's enjoying himself, and doing okay, and doing what he wants to do."

Cathi Triplett
WIFE OF KIRK TRIPLETT

Unlike Molly Damron, Cathi Triplett made her adjustment long ago. She has been on the road with her husband, Kirk, ever since 1990, his rookie year on TOUR. Since she grew up a Navy brat, it could have been worse.

"I was used to traveling, but I still didn't know what to expect. That first year was kind of nervy. Figuring out where to stay is *big*," says Cathi.

CATHI TRIPLETT CHATS WITH FANS—THE INTERNATIONAL

At first, she explains, the natural tendency is to try to cut costs, "so you end up some place where there's a wedding reception keeping you up all night. We finally figured out that sometimes spending more money turns out to be worth it. Like Kirk used to say, 'You eat like a hot dog, you play like a hot dog.'"

Cathi says her biggest surprise as a TOUR wife was the wonderful treatment afforded to the players' families. "You find yourself sitting up on a deck overlooking 18, buffets of food, people around asking, 'What can we do for you?' A lot of tournaments have activities specifically for the wives. It's like they just want to take care of you and want it to be a fun week. It was really more than I expected."

A person could almost get spoiled. "The kids get home," says Cathi, "and they want it to be just like out on TOUR. Sorry, it's the real world at home."

How do Cathi and Kirk deal with the vicissitudes of the golfer's life? "For both of us," says Cathi, "that's what the family is for. That is our priority."

Still, Cathi admits, some weeks are tougher than others, and some years, too. There are no guarantees out here, and the threat of losing his card hangs over a player's head—and his family's—like the sword of Damocles.

"It was hard at the beginning of this year," says Cathi. "Kirk got hurt his second week out, and I think that slowed him down. Usually he's secured his card by March or April, and that didn't happen until late this year. Then, too, we're moving into a new house, so there's been some stress."

And that's where family comes back in. "On the

KIRK TRIPLETT READS TO DAUGHTER ALEXIS—THE INTERNATIONAL

bad days, we just make the most of our family. That's the most important thing anyway."

Of course, in 13 straight years on the TOUR, Triplett has had plenty of good days, one of which he still remembers vividly. "It was my first year, 1990, in San Diego, maybe the sixth or seventh event of the year. I had made a couple of cuts, missed a couple, but in that

Once his mind was set, three failed attempts at Q-School didn't discourage him. "The key is to constantly push yourself to get better," says Triplett. "It took a long time to get on tour, but so long as I was getting better I didn't want to stop. There were times I thought about giving it up, but looking back, I am sure glad I stuck with it."

The good days got better with his first TOUR victory at the 2000 Nissan Open. The following year he had top-ten finishes in three of the four majors, along with a 2nd in the Michelob Championship. But Cathi is quick to point out that the good days, too, need to be kept in perspective. "Good days or bad," she says, "you try not to live and die by it. Otherwise I would probably have a heart attack. When Kirk gets home, what happened on the golf course is forgotten."

Without taking too much credit, Cathi thinks that how to separate golf from life was a lesson that she might have helped Triplett learn. "We started dating before he went to Q-school for the fourth time, and I think maybe part of the reason he made it through that time was because he had other things going on in his life. It made the golf not as important as living life."

For his part, Triplett gives Cathi *all* the credit. It's not just that she's been willing to make this commitment to his career. Nor that she's willing to do all the hard work for the family, which, Triplett says, is hard enough at home but much harder on the road. Even more important than these is Cathi's attitude, which Triplett says is crucial to helping him stay on an even keel.

"Somehow she was like that from the very start," Triplett explains. "If I hit a good one, she didn't get too

tournament I finished tied for 4th and made something like $32,000. Man, I thought that was all the money in the world, and it gave me confidence that I could make a living out here."

The self-confessed late bloomer went to college to get his degree in Civil Engineering and only after graduation began to contemplate playing golf professionally.

excited, and if I hit a bad one she wasn't over there hanging her head and moaning, 'Oh no.'"

Cathi wants him to do well, of course, says Triplett. "But she understands that that means doing my best, trying my hardest, and if doesn't work out, trying again. Not that that's easy. You can get very frustrated out there and lose your composure. That's why it helps to have her out there. She knows that you can't get caught up in the moment, and she helps me remember that."

Cathi is an even-tempered optimist, says Triplett, which helps him visualize success. "I'll hit it in the wrong place, a place where I've done poorly from before, and I'll think, 'Here we go again.' But I know Cathi is thinking, 'Hey, you've also escaped from there, you've made a birdie from there.' I know she's remembering the good things, and it lifts me up."

In the meantime, Cathi and Kirk are making the best of life on the road with four young children, including son Kobe, whom they adopted in May. Probably more than most TOUR moms, Cathi appreciates the TOUR's efforts to make mothers and children feel at home—the hospitality, the gifts for the kids, the special touches offered at virtually every event.

A favorite, says Cathi, is the beautiful spa at the hotel they stay at for the Byron Nelson—with the two free treatments offered to the TOUR wives. Cathi is amused that the TOUR has figured out how important it is to entice the wives.

"If momma wants to go, daddy better go," she says, 'cause if momma's happy, everybody's happy. That applies out here as well."

Marci Blake
WIFE OF JAY DON BLAKE

Remarkably, it's not enough for these TOUR wives to travel with their husbands, manage an on-the-road-household, and keep the collective family's chin up when the putts aren't dropping and all the lies come up bad.

Marci Blake, wife of 16-year TOUR veteran Jay Don Blake, is president of the TOUR Wives Association, an organization that takes whatever energy these women have left over and devotes it to charitable endeavors.

"You know the PGA TOUR contributes millions of dollars every year to charities of every kind," says Marci, "but all our charity work is directed to children."

To cite just one example, Marci talks about the Target House in Memphis, Tennessee. It's a recreation facility for children with cancer, to which the TOUR Wives Association recently donated an outside play area. "We went out there just recently," Marci explains, "and delivered the final payment. We played miniature golf with the kids, had a barbecue, and gave them our check. We had three years to raise the money, but we paid it off sooner, and that's such a good feeling. It was a wonderful moment."

With the wives setting the example, TOUR players pitched in too. "Anna and Tim Herron donated the special van that's used to transport the kids, and Tiger Woods donated the library—a terrific contribution."

Coming up soon, says Marci, is a two-mile charity walk for the September 11 disaster relief fund. "It's the

PGA TOUR WIVES GIVE JENNIFER BECKMAN A BABY SHOWER—THE INTERNATIONAL

most awesome feeling in the world to be on the board," she says, "to help direct money to all the different charities."

One of her annual favorites is the Wives Golf/Husbands Caddy Tournament, held in Phoenix every spring and organized by Cathi Triplett. "We hold it on Tuesday afternoon," says Marci. "The wives play a nine-hole scramble, and our husbands caddy for us. It's hilarious. There are absolutely no rules." It was especially fun this past year, she says, because her team won. She gives all the credit to Jennifer Smith (Jerry's wife), whom she describes as an awesome player.

Winning was wonderful, says Marci, but what felt better was raising more than $80,000 that one day.

The association kicks off every year with a mem-

explains Marci, "so during that tournament we do a lot of our planning for the year."

Marci describes the wives and children who travel with their husbands as one big, loving family. "Everybody is so nice, so caring, and so helpful," she says. "We're not just out here cheering for our husbands. People are getting married, people are having babies, so there's always a shower or something to bring us close together." Marci laughs. "Oh my gosh, it's wonderful when new babies come out to their first tournament. The dads are so proud, showing off their kids. It's special."

And if the life is sometimes strenuous, Marci finds much to be thankful for. "We get to see all these beautiful sites," she says, "like here at Castle Pines [in Colorado]—absolutely gorgeous. And believe me, we stop to smell the roses. Not to mention the fact

ber-wide meeting at Pebble Beach in late January, followed by the season's inaugural board meeting.

That organizational meeting is followed by another board meeting at The Players Championship in March in Jacksonville. "That's where the corporate offices are,"

that we get to be with our husbands. I'm just grateful for all of it. You know, I could be working retail."

Four-year-old Miranda travels with Marci and Jay Don, and Marci makes sure that the youngster gets an eyeful. "It's so fabulous," she says. "We can drive up to

Vail and see the buffalo and the elk. I am telling you, we spend hours oohing and ahhing. There's always something to see and do."

With all she has going on, is there any time left over to follow her husband during tournament play? "I can't stand to miss a single shot," she declares, which reminds her of another amenity the TOUR wives enjoy—"the wonderful ladies who take care of our children at the TOUR day care center."

The TOUR Wives Association—and husband Jay Don—are clearly in good hands. "My husband plays 30 weeks a year," says Marci, "and I never miss an event."

Ralph Azinger
PAUL AZINGER'S FATHER

By the time the wife comes onto the scene, the hand has already been dealt. With parents it's different. They see the bundle of talent in its embryonic stage and then have to make some decisions.

Paul Azinger's father, Ralph, remembers exactly when he realized that Paul had something special. "It was when Paul was about nine," he says. "I heard a 'whoosh' in his swing that his three brothers didn't have, that my wife didn't have, that I didn't have."

RALPH AZINGER WATCHES SON PAUL FINISH ROUND—THE PLAYERS CHAMPIONSHIP

It wasn't just the golf swing, though. "He played everything," says Ralph, "and he was excellent at everything. He had supreme hand-eye coordination and a fierce determination to win—whether at billiards, tennis, golf, whatever. Those two things combined to forge his career."

To help Paul develop, Ralph says he mostly stayed out of the way. "Paul was about 12," Ralph recalls, "when he started hitting the ball past me off the tee. I could see that he had a very strong grip, and I asked a pro if I should do anything about that—you know, get him some lessons. The pro advised me to do nothing, to let it grow on its own, and that was the wisest thing that young pro could have said."

Ralph says he admires Tiger Woods' father and Serena and Venus Williams' father, men who have had a strong hand in directing their children's careers, but he wouldn't have wanted to do it that way. "I think most of us like to live in our world and let their kids make their own way in theirs. And besides," he adds, "a lot of times these kids burn out when they are pressed too hard."

Though Ralph no longer plays—"the spirit is willing but the body is too beat up"—he loves walking the course when Paul is playing. And though he couldn't be there in person, he and the family were gathered around the TV when Paul won the PGA Championship in a sudden death playoff over Greg Norman in 1993. "We practically jumped through the roof," remembers Ralph. "Even Paul's nephew, my three-year-old grandson—the kid knew what his uncle had done."

KIDS LISTEN TO JUSTIN LEONARD AT GOLF CLINIC—BYRON NELSON CLASSIC

Higher Rewards

At any PGA TOUR event, you'll see it happening. The game's history is celebrated, its future is solidified, and its community is enriched.

During the three days before tournament play begins, virtually every TOUR stop features a "youth day"—the long-range purpose of which is to instill knowledge and love of the game in those people who will eventually become its standard bearers. Maybe kids get in free to watch the practice rounds; maybe they get to participate in a clinic and enjoy up-close instruction from famous players or teachers. In many cases, special programs are offered to less-advantaged children, to give these youngsters an unlooked-for opportunity to see that this great game can be theirs, as well.

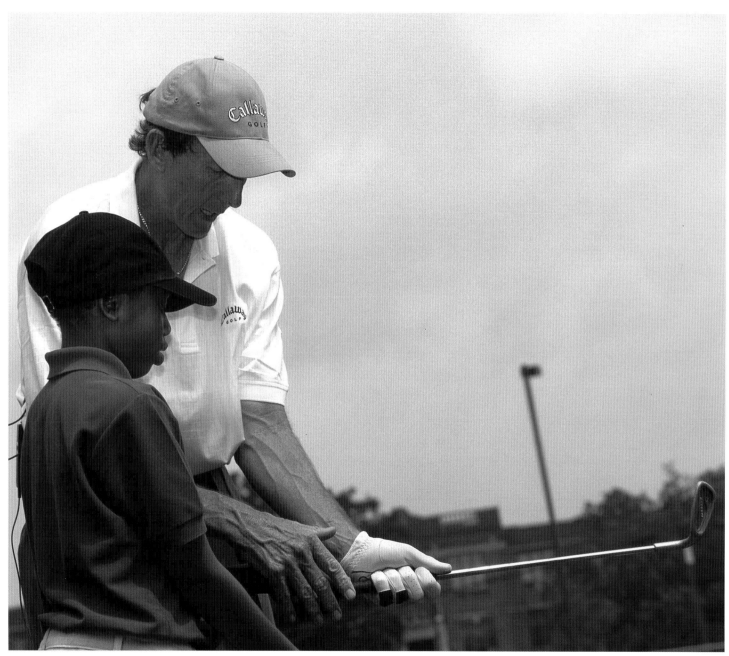

DAVID LEADBETTER DEMONSTRATES PROPER GRIP DURING CLINIC AT J. ERIK JONSSON COMMUNITY SCHOOL.

As part of the 2002 Verizon Byron Nelson Classic, for example, the Salesmanship Club of Dallas, which sponsors the tournament, brought David Leadbetter to a sixth-grade class at J. Erik Jonsson Community School, where the world-renowned instructor conducted an hour-long session. Beginning with the fundamentals of gripping the club, Leadbetter freely dispensed his valuable wisdom to a rapt young audience.

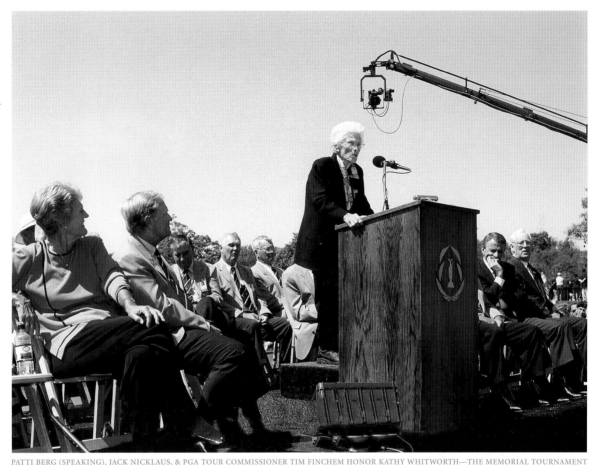

PATTI BERG (SPEAKING), JACK NICKLAUS, & PGA TOUR COMMISSIONER TIM FINCHEM HONOR KATHY WHITWORTH—THE MEMORIAL TOURNAMENT

Later, back at the tournament site, kids were the happy beneficiaries of additional instruction—as well as a PGA TOUR "club give-away." Tiger Woods, watch out!

Meanwhile, at Jack Nicklaus's Memorial Tournament at Muirfield in Dublin, Ohio, the Captains Club pays homage to the game's history while sustaining its stature and traditions. While Nicklaus originally conceived of the organization as a way to help foster the tournament, the Captains Club also each year designates as its honoree a person "who has made a significant contribution to the game of golf." An exception was made in 2002, when the club honored not just one but two of golf's legendary champions: Bobby Locke (posthumously), who won 64 tournaments worldwide—including four British Opens—during his 24-year career; and Kathy Whitworth, seven-time LPGA Player of the Year.

Whitworth, who grew up hitting golf balls into cow pastures in New Mexico, won her first event, the

promotes golf as a means of rehabilitation for people with disabilities.

And then there's Dennis Walters, who brings his own very special dimension to a number of PGA TOUR events—not to mention LPGA and Senior Tour events, amateur and collegiate tournaments, business seminars, trade shows, and a good many television programs as well. What's the story behind "Golf's Most Inspiring Hour"?

Walters fell in love with golf at age eight. He was a New Jersey junior champion, placed 11th in the U.S. Amateur, and played collegiate golf at North Texas State. But in 1974, a golf cart accident left him

Kelly Girl in Baltimore, in 1962. It's an understatement to say that she was just getting started. Her last LPGA victory, the United Virginia Bank Classic in 1985, was her 88th. Along the way, she had surpassed Mickey Wright (82 wins) and then Sam Snead (84) to accumulate more professional titles than any other player, man or woman.

Whitworth still plays occasionally on the LPGA Tour, but spends most of her time as one of the game's great all-time ambassadors—as when she was the featured speaker at the 2002 Memorial Breakfast. A highlight of tournament week, the breakfast serves as a fundraiser for Fore Hope, a charitable organization that

paralyzed from the waist down. His golfing days were over—or would have been, except that Walters refused to give up the game he loved.

After months of rehab and therapy, he recalls, "I was hitting balls from a wheelchair and starting to get them airborne, but I had no way of getting around the golf course." The solution was to cut the legs off of a bar stool and mount the seat on a golf cart. Once mobile, Walters wasted no time conceiving and developing "The Dennis Walters Golf Show," an hour of incredible golf wizardry and great entertainment.

It's more than that, of course. Walters is an inspiration, and his show is all about overcoming obstacles and pursuing dreams. His life's lesson is especially important to youngsters, and it's no wonder that he's been hailed by Tiger Woods for his work at the Tiger Woods Foundation Junior Golf Clinics. No wonder, too, that because

of his outstanding contributions to the game, he was recently named the fifth honorary lifetime member of the Professional Golfers' Association of America.

And so the old game is cherished, nurtured, and lovingly bequeathed to the generations that follow. "These guys are good," runs the tagline, and the game just gets better.

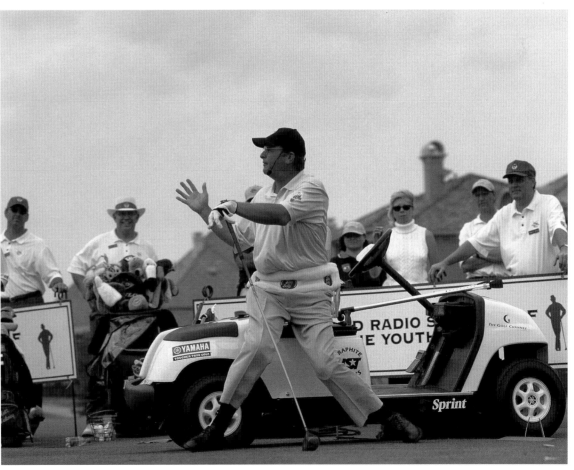

DENNIS WALTERS PERFORMING HIS INSPIRATIONAL GOLF SHOW—THE MEMORIAL TOURNAMENT

Off to Work

Everybody agrees that golf is played "between the ears." But for some reason, nobody has stopped *working* on it. Drop down below the ears and you find yourself in a very physical world—a world of hips, shoulders, and left arms; a world of rhythm, tempo, and swing plane; a world of hands and feet and alignment.

You find yourself in a world of practice. And that's where you'll find professional golfers: on the driving range, on the putting green, huddled up with teachers (Butch Harmon, Dave Pelz, David Leadbetter) just as famous as their world-class pupils. Or—in one of golf's wonderful paradoxes—huddled up with rival players. Well, why shouldn't Stuart Appleby give a putting lesson to Hank Kuehne? In a very real sense, golfers don't compete against other golfers. They try to beat the golf course. They try not to beat themselves.

Which is why they practice . . . and practice . . . and practice. There's a theory here—another of golf's conundrums. Actually, the players would rather not play the game with their minds. They would rather play it with their clubs. They would rather have their bodies take over and their minds take a hike.

DAVID GOSSETT & CADDY WORK THROUGH PUTTING DRILL—THE INTERNATIONAL

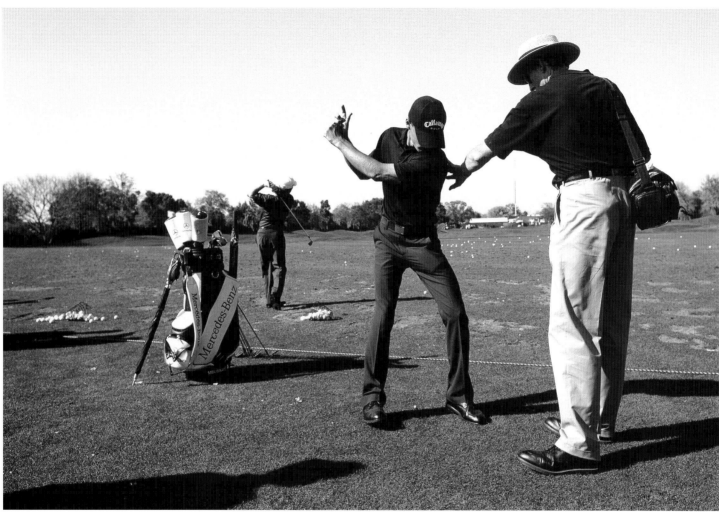

That's what Charles Howell, one of the brightest young stars on the TOUR, means when he talks about "letting it happen." Howell, 36th on the money list in his first full year on the TOUR, hasn't won a tournament yet, but he has come close. "And those times when I've been in good position, when I've been close, have been times

when I wasn't really thinking about it, just trying to let it happen. When the win comes, I'll be there waiting for it."

In the meantime he'll keep working with David Leadbetter, whom he credits with getting him where he is today. "We work on my swing plane," says Howell, "and on calming my body motion down, on fine-tuning

my torso speed. Rhythm, timing, tempo—we keep working on those things. The main thing now is to just keep learning, and hopefully break through."

And Brian Henninger, to take another example, will keep working with Jim Hardy, who has been helping him since he began to struggle—as he puts it—during the 2001 season. Interestingly, Henninger resisted seeking help, but now, he says, "I've come full circle. I've always been very independent, and for a long time I just shied away from all the instruction, 'cause I thought it was a fifty-fifty thing. You can either go forward or go backward."

He believes he's going forward, and, like Howell, Henninger says he's still learning, working to get bet-

BRIAN HENNINGER PLANS SHOT AT 17TH TEE—BYRON NELSON CLASSIC

ter. "I feel like I am improving, and the stats show that. Honestly, I think the sky's still the limit for me in the next five to ten years."

Part of that drive to get better, of course, is

inspired by the nature of the game. "I've never felt like I've reached my potential with this game," says Henninger, "and it drives me crazy."

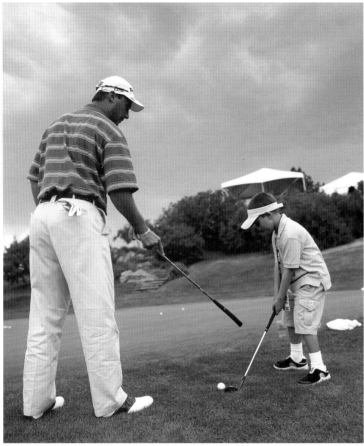

CHRIS DEMARCO GIVES SON CHRISTIAN A POINTER—THE INTERNATIONAL

So they keep practicing. They all practice. They may not all practice as much as Vijay Singh, who, when he's finished practicing right-handed, hits a couple of buckets left-handed. But they all keep practicing.

There's Chris DiMarco, 2002 Phoenix Open champion and in the top 20 on the money list with close to $2 million in earnings. He's practicing. In fact, when DiMarco gets tired of practicing, he makes his son take over.

VIJAY SINGH WATCHES DRIVE AT 18TH HOLE—THE MEMORIAL TOURNAMENT

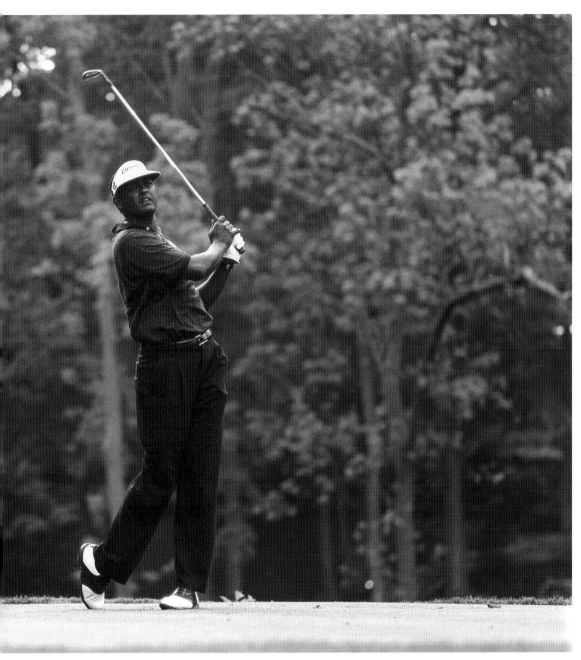

Even Ernie Els, the man with the most effortless swing in golf, has been seen on the practice range. Maybe that's why he's the third-ranked player in the world, with two U.S. Opens and the current British Open championship on his stellar record.

Practice doesn't make perfect, of course. Another of golf's little riddles: nobody has ever played perfectly, and nobody ever will. After David Duval shot his 59 to win the 1999 Bob Hope Chrysler Classic, he told the TV interviewer that he was headed over to the range because there were a few things he needed to work on. (Okay, maybe he was joking.)

But if there have never been any perfect rounds, these players have shot some mighty good ones. Steve Lowery's 68 in the opening round at the 2002 Byron Nelson was merely a hint at the streak he would go on a few weeks later. A 64 in the third round of the Greater Milwaukee Open propelled Lowery to three 2nd-place finishes over a span of six weeks and his best-ever year on the TOUR.

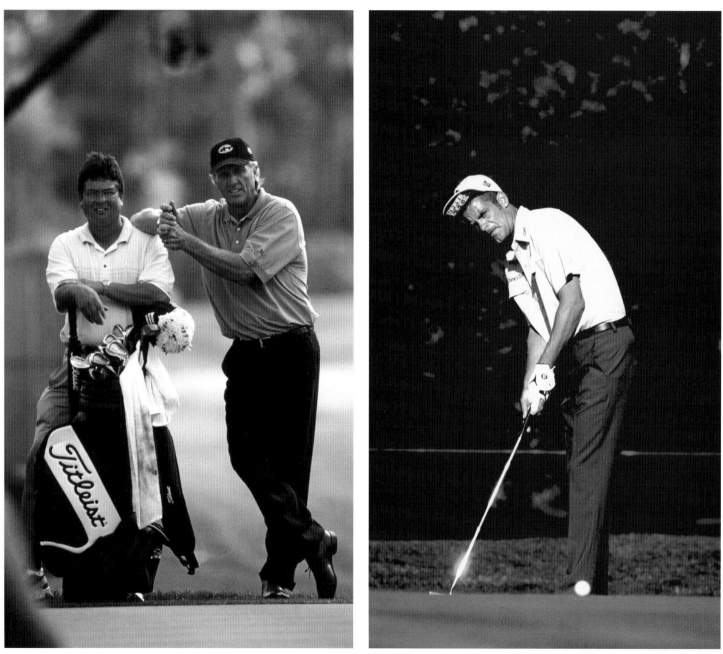

GREG NORMAN AND CADDY DISCUSS FELLOW GOLFER'S GRIP—THE PLAYERS CHAMPIONSHIP JESPER PARNEVIK STARES DOWN PUTT—THE PLAYERS CHAMPIONSHIP

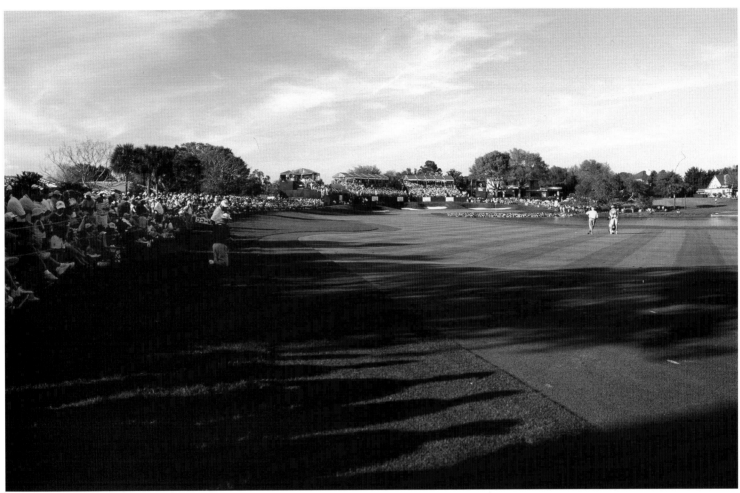

Jesper Parnevik may have missed the cut in The 2002 Players Championship, but the stylish Swede knows how to go low, and he keeps his victory cigar close at hand. Parnevik has fourteen victories worldwide, and his 64-65 in the final rounds of the 2000 Hope Classic propelled him to one of his five PGA TOUR wins.

Greg Norman had to withdraw from the 2002 Bay Hill Classic, but the Shark has plenty of fine memories to share with John Daly. His 63 in the second round at Turnberry helped him to his first British Open title in 1986, and seven years later he scorched Nick Faldo with a 64 to win at Royal St. George. Norman's 18 wins on the PGA TOUR pale in comparison to his 56 victories internationally.

Sergio Garcia says he's been working on his game since his father, a golf pro, put a club in his hand at age three. It began to pay off as soon as he stepped onto the tee box in his PGA TOUR start: he fired a 62 in the opening round of the 1999 Byron Nelson Classic. In 2002, his steady four-under total and 4th-place finish at The Players

ROBERT DAMRON TELLS SERGIO GARCIA STORY AT 1ST TEE—THE MEMORIAL TOURNAMENT

Championship has been one of several highlights. He started the year by closing with a 64 to win The Mercedes Championship, fired a 67 in the third round of the U.S. Open for another 4th place, and went way low with a 62 in the final round of the American Express Championship.

And when one player does have a great round, his fellows are likely to applaud. Of golf's many unique characteristics, the camaraderie among the players is perhaps the most remarkable. The two words one player is most likely to utter to his opponent—regardless of how heated the competition—are "Nice shot." On the other hand, when you see two players huddled together in friendly conversation on the course, maybe they're talking about how to beat Tiger.

GREG NORMAN & JOHN DALY CHAT AT 1ST TEE—BAY HILL INVITATIONAL

CURTIS STRANGE TALKING WITH MEDIA CONSULTANT LEE PATTERSON—BAY HILL INVITATIONAL

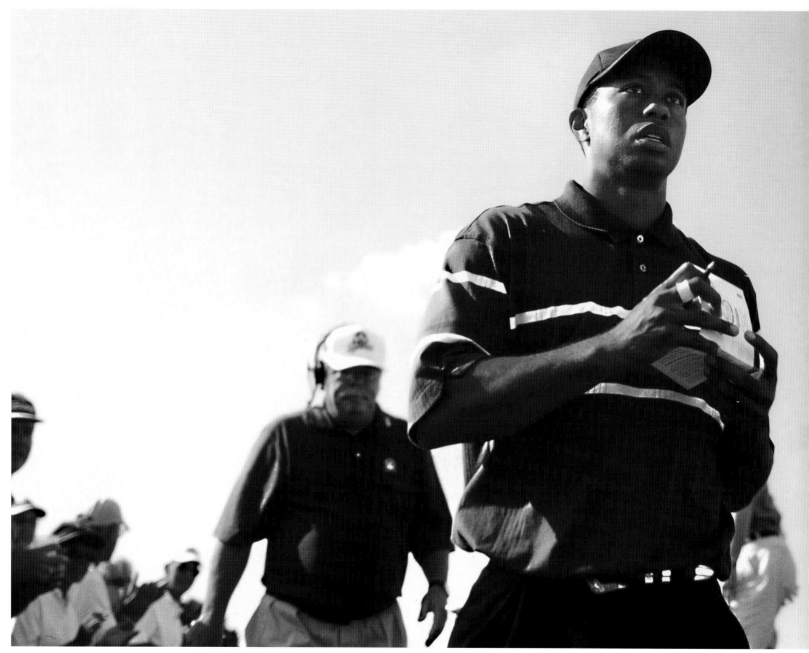

TIGER WOODS AFTER BIRDIE ON HOLE NO. 9 MOUNTS ONE OF HIS FABLED CHARGES TO VICTORY—BAY HILL INVITATIONAL

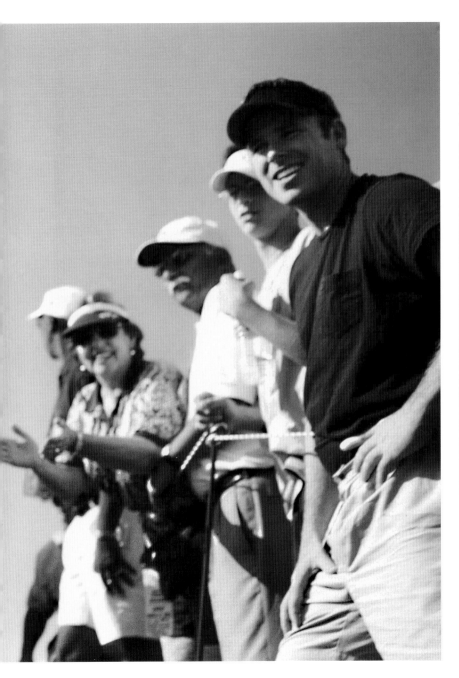

Because, surely, Tiger is the one player who the other guys wish would *quit* working on his game. But no, he won't. So how did Woods do in the 2002 U.S. Open? He won, firing a 67 in the opening round and never looking back. How about the Masters? He won, nailing

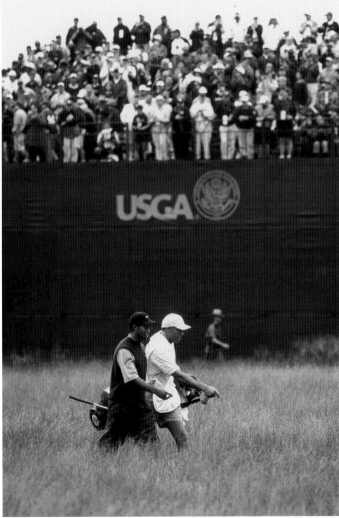

FANS CHEER TIGER WOODS AS HE APPROACHES 17TH HOLE—BYRON NELSON CLASSIC

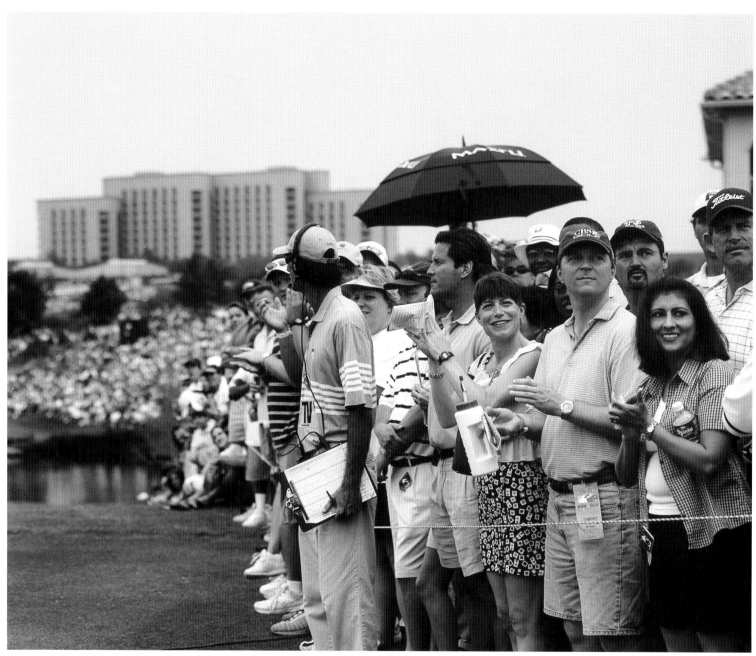

FANS GREET TIGER WOODS AS HE WALKS TO 1ST TEE—U.S. OPEN CHAMPIONSHIP

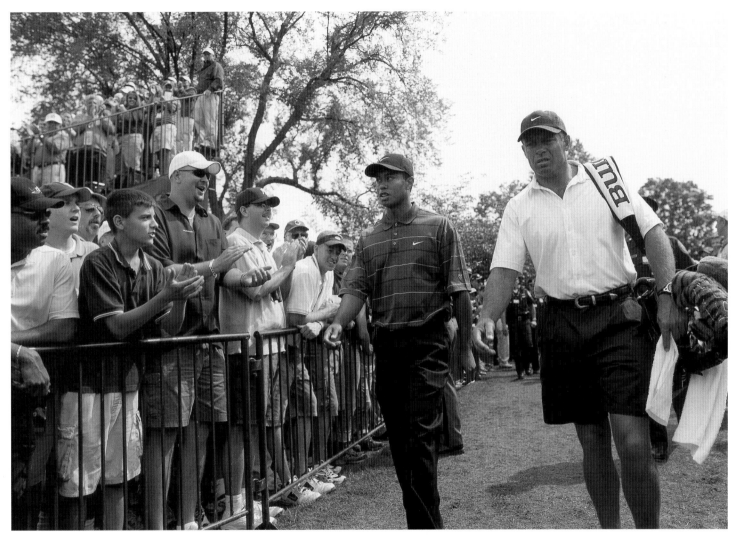

TIGER WOODS TEES OFF, HOLE NO. 1—THE MEMORIAL TOURNAMENT

down his third green jacket with a 66 in the third round. How about the Bay Hill Classic, the Buick Open, the American Express Championship? Won. Won. Won. It was the fourth year in a row he's won at least five events, a feat not accomplished since Arnold Palmer did it 40 years ago. But of all his 34 PGA TOUR wins, the most historically significant might have been his victory in the 2001 Masters, which clinched the Tiger Slam— making him the holder at that time of all four major championships.

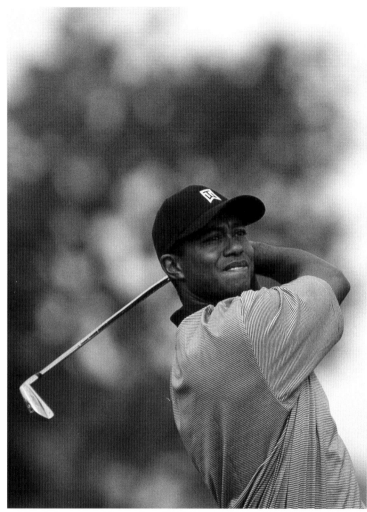

TIGER WOODS TEES OFF, HOLE NO. 1—THE MEMORIAL TOURNAMENT

Tiger's still working on it. He wants to win six events a year and, like he says in the commercial, "lots more majors."

But that's okay. The other guys are going to keep working, too. They may not be threatening Nicklaus's records, but they've got their reasons.

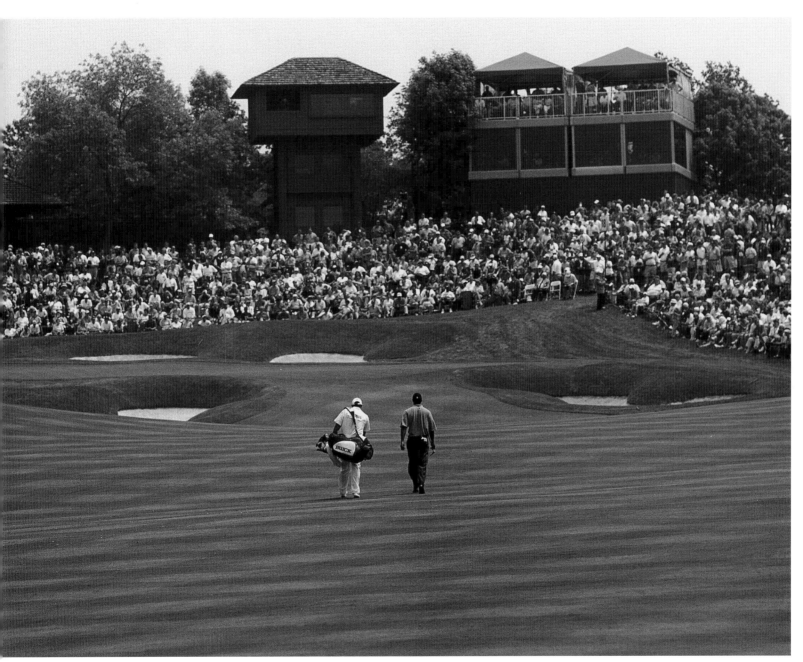

TIGER WOODS & CADDY MARCH UP 18TH FAIRWAY—THE MEMORIAL TOURNAMENT

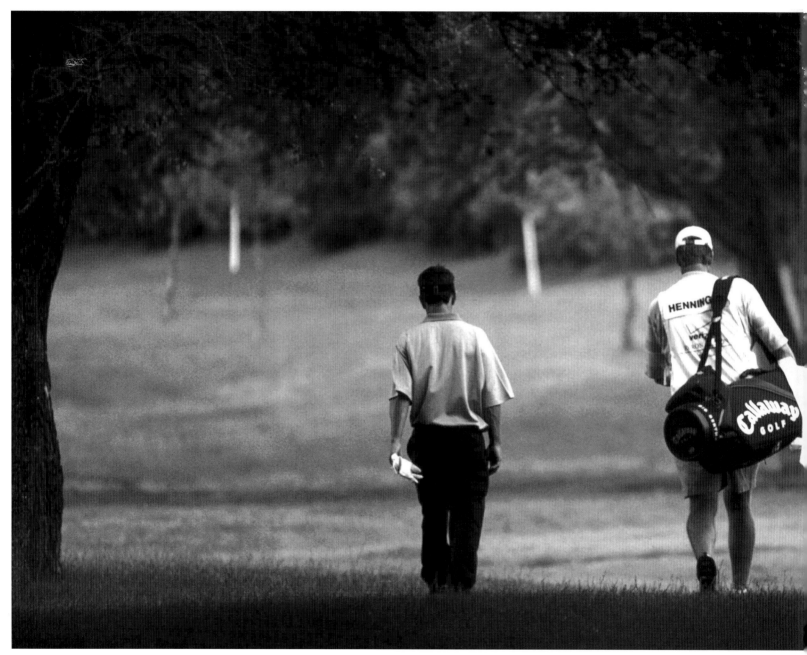

BRIAN HENNINGER & CADDY WALK TO BALL ON 6TH HOLE—BYRON NELSON CLASSIC

Brian Henninger remembers his win at the 1999 State Farm Bureau Classic. "I had such a great perspective that week," he recalls. "That was kind of peak performance, a peak of who I am, and how I would like to act and feel." To have that feeling again is plenty of motivation for Henninger, and so is a quick glance down below, where the guys on the BUY.COM Tour go to work. "There are plenty of guys lined up," he says, "just waiting to take my job."

And then there's 44-year-old Dan Forsman, who won the 2002 SEI Pennsylvania Classic to break a 10-year, 246-tournament drought. A lot of people would have walked off the job during those 10 years, and Forsman admits that he has thought about it. "Sometimes I get out of bed and [everything] hurts," he said after the emotional win. "It's those moments when I'm wondering, 'Is it worth it?'"

It's easy to doubt—"to think our best days are behind us." But, said Forsman, "I was hopeful that if I kept at it, some good things would come my way."

Golf is a game, but to play with the gentlemen on the PGA TOUR, you've got pick up your lunch pail and go to work.

Acknowledgments

First among those to whom I owe unconditional appreciation is Bob Combs, Senior Vice-President for Communications and Public Relations at the PGA TOUR. He patiently helped me transform vague notions into viable book concepts and provided unwavering support without which the photography for the project could not have been done. I want to thank Commissioner Tim Finchem for backing the project from the beginning and then, at its conclusion, generously agreeing to introduce the book. Many individuals on the PGA Tour staff tendered vital and timely assistance: John Snow, Stan Badz, Chris Condon, Jim Ault, Deborah Carrillo, Chris Smith, Ward Clayton, DeniseTaylor, Sid Wilson, Marty Caffey, Dave Lancer, Andy Pazder, Patrick Donahue, Steve Rankin, Sara Moores, Joan Alexander, John Bush, Todd Budnick, Luis Salcedo, Jerri Moon, Meg Roy, and Evanne DiGenti.

Media Directors at each tournament I photographed graciously arranged housing, fed, and informed me. To each of them I extend my appreciation: Jeff Blaugrund, Tracy Dent, Ana Leaird, Mike Prusinski, John Stelzer, Craig Smith, Jack Doak & Kaye Kessler. A number of tournament officials provided invaluable help, especially Ollie Nutt and Cathy Scherzer of the Monterey Peninsula Foundation and Cullum Thompson from the Salesmanship Club. I particularly want to think Mike Davis, U.S. Open Championship Director, and Hal Slaton, Tournament Chairman at the Bay Hill Invitational, for allowing me to photograph them in the midst of their very busy Tournament days.

I owe a special thanks to Kirk and Cathi Triplett, Molly Damron, Marci Blake, and Brian Henninger for sharing with me aspects of their TOUR lives.

I want to thank Lance Barrow and his CBS Sports team members David Feherty, Gary McCord, Peter Kostis, Kerry Brooks, Jim Nance, and Ken Venturi for allowing me a brief glimpse into their world. I wish to thank Win Padgett, Dave Kellogg, and Dave Anderson for timely introductions, Aidan and Lisa Bradley for their warm hospitality, and Jules Alexander for the bond of friendship and the fine photograph he allowed us to use on the book jacket.

Of course, without the Lionheart Books team there would be no book. I hope Michael Reagan knows how much I value his editorial judgment; Carley Brown understands how much I appreciate her selection and layout of the pictures; Deb Murphy realizes how grateful I am that she kept the production organized; and Susie Ehring for so quickly transcribing the interviews. Again, I stand in awe of the masterful job John Yow did weaving disjointed interviews into stories that flow with a grace that makes them a pleasure to read.

I appreciate Alan Stark's early support and valuable suggestions and Kelly Gilbert at Andrews McMeel Publishing for seeing the project through to publication.

Most of all, I want to thank Susan Drinker, my beloved wife and partner. It is her highly developed aesthetic that time and again I turn to for guidance, her unerring eye for fine detail I trust to catch flaws, and her unflagging encouragement that is always there to give me a lift when momentum stalls. She applied every ounce of her talent and energy to the task of scanning and optimizing the photographs for this book. Because she strives to leave no tracks and her skill is so great, few readers will ever appreciate how very much we owe to her for the quality of the images in the book.